The Fox Book

by Jane Russ

GRAFFEG

Dedications

Dedicated to the volunteers throughout
the United Kingdom who give of their
time and effort to support wildlife.
Thank you.

Contents

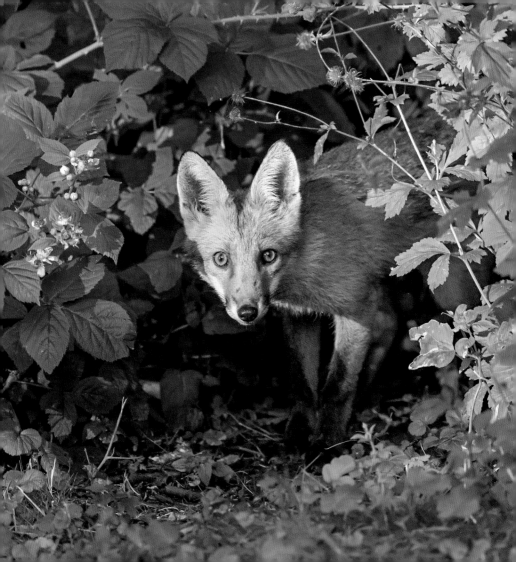

The Fox Project

This book has been produced with the support of The Fox Project.

'Who needs a tiger on TV when you have a fox on your lawn? Every bit as beautiful, immensely successful and, most importantly, yours to enjoy in the flesh. And when properly understood, and treated, an asset to your community – nothing beats a fox!' CHRIS PACKHAM, PATRON, THE FOX PROJECT

The Fox Project was established in 1991 as a specialist Wildlife Information Bureau and Fox Deterrence Consultancy. Since 1993 it has incorporated a Wildlife Hospital which admits and treats around 700 foxes per year, including 250 cubs. It appears regularly on TV, radio and other media, both in the UK and internationally, and has received awards from the RSPCA and the International Fund for Animal Welfare, among others.

The Wildlife Information Bureau regularly advises and provides information on all aspects of the red fox to national and local government and to the general public. It was established to supply science-based information on a species whose character has divided public opinion and often been misrepresented.

The Fox Deterrence Consultancy
provides do-it-yourself information
on simple, humane and non-lethal
methods of resolving conflict with
urban foxes. It works with, and
recommends, professional call-
out consultancies, which exclude
both destruction and relocation,
and provides an alternative to old-
fashioned methods of 'pest control'.

The Wildlife Ambulance Service
operates over a 60 x 70 mile range
over parts of Kent, Surrey, east and
west Sussex and south-east London,
dealing with sick and injured foxes
and abandoned fox cubs. It works
with a large team of volunteer
rescuers, fosterers and rehabbers
to provide their care and treatment.
With the involvement of farmers,

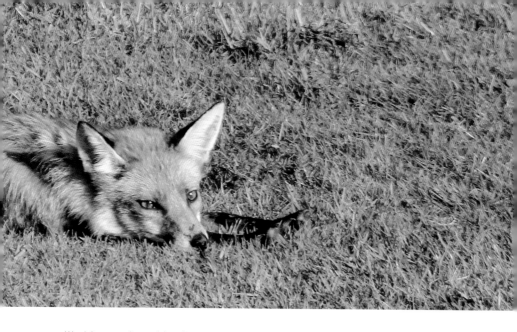

smallholders and rural landowners,
the organisation maintains a
policy of returning recovered adult
animals to their home territories
and incorporates a programme of
controlled rehabilitation to allow
hand-raised fox cubs to re-enter
the wild.

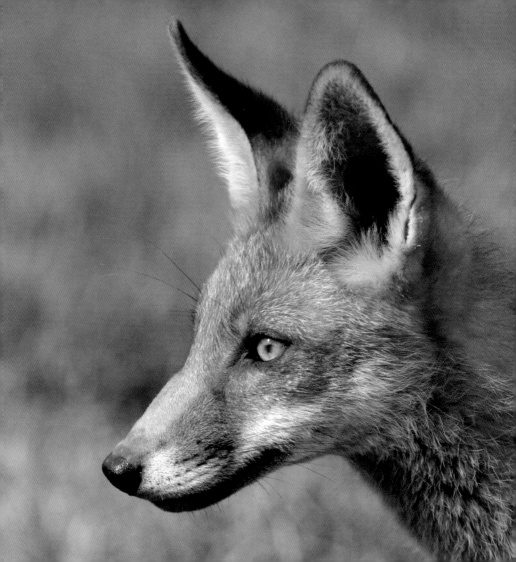

The life cycle of the fox

Of the twelve species of fox belonging to the *Vulpes* genus, the most common is the red fox *Vulpes vulpes*. It is a genus that spreads its net wide and it can be found on almost every continent. Potentially, a fox can live up to twelve years but usually, owing to road accidents, hunting and disease, they actually only live for about two or three.

Foxes breed only once a year and a dog may choose a vixen in mid-December and follow her around for several weeks before she is actually in season and ready to mate. The vixen may prepare several potential earths to give her a choice when she is ready to give birth. Foxes are happy to use the earths of other animals such as badger setts and abandoned rabbit warrens, whilst urban foxes may find that space under your shed just the thing. Put simply, a den should be secure, dry and private, close to a food supply and water.

Oestrus lasts approximately three days and the process is proclaimed to all with the loud shouting, barking cry even urbanites are used to hearing in January/early February. Once she is ready, there will be repeated mating between the dog and the vixen, sometimes there will be locking or knotting together to ensure the success of this single annual attempt at conception.

Pregnancy lasts on average fifty-three days into March and April. During this period and after the birth, the vixen is dependent on the dog fox to feed her as she rarely leaves the den. The four to five cubs are born blind and deaf, with short, almost black, fur. They are very dependent on the warmth of the mother to survive, and, as anyone who has reared a cub will verify, temperature is all important for the first two to three weeks of life.

The cubs' eyes will open at about fourteen days, but hesitant steps into the outside world don't occur until four weeks at the earliest. If necessary the parents will move the

cubs one by one, if the den has been compromised in some way or if they feel they need a larger one with more room underground.

The cubs will take some solid food and will be fully weaned within roughly six weeks. Gradually the vixen will spend more time away from the den, foraging with the dog to keep the ever growing family contented. Non-breeding members of their larger fox community (perhaps cubs from the previous year) may help the parents to feed the cubs too, as loose family groups can form a strong bond.

Foxes not only survive on live hunted prey such as rodents, rabbits and birds, but are omnivores enjoying grubs, earthworms, beetles and fruit in season – apples, pears and blackberries. Naturally, they like the easy option of it and if, for instance, they have access to bird food which includes peanuts, they'll take that. The Department for Environment and Rural Affairs

(DEFRA) has put paid to the old 'foxes live off farmers livestock' tale by stating that fox predation on livestock is in fact insignificant. Foxes will take dead lambs and any other carrion, but their undeserved label as 'agricultural pests' persists, despite scientific research revealing that their predation on rabbits and voles means that they are probably beneficial to the farming industry.

During the time when they are being fed by their parents and 'aunts', the returning food bearers are greeted with much enthusiasm by the cubs. The litter members not fully weaned may immediately latch onto the vixen, whilst others squabble noisily and carry off whatever has been brought home for them. Once the cubs are left alone during parental food expeditions they, like young mammals the world over, will practice with each other the skills they will need for life. Play fighting, grooming, 'hunting' the remnants of the previous meal: all these will have

In the autumn through to November juvenile dogs and some vixens will be looking for territories of their own, often encouraged by the parents, particularly the vixen.

an effect on how prepared they are to take on living the quite solitary life of an adult fox.

By mid to late April, the annual moult will be underway. It is the end of the breeding season and most adult animals will be looking rather scruffy. The vixen may have a separate resting place now as the family are pretty boisterous.

Through the summer the cubs will get less food brought to them and need to begin foraging for themselves. Eventually they will be living independently but 'socially' with other family members, dropping in and out of the larger sibling group. Of course, they will happily take anything extra in the way of food if offered by the parents.

In the autumn through to November juvenile dogs and some vixens will be looking for territories of their own, often encouraged by the parents, particularly the vixen. Once their lush winter coats are fully in, it may be hard to tell parents and cubs apart. This dispersal period is often noted for loud barking and shouting. This is unfortunately the part of the year when you often see small foxes dead at the side of the road, killed by traffic.

Then, the whole process starts again. Males and females pair-up to establish their territory and search for suitable birth-dens, which may be ones used before or new sites.

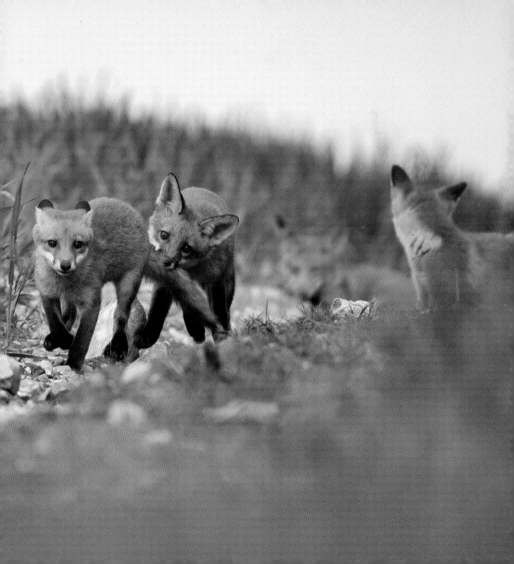

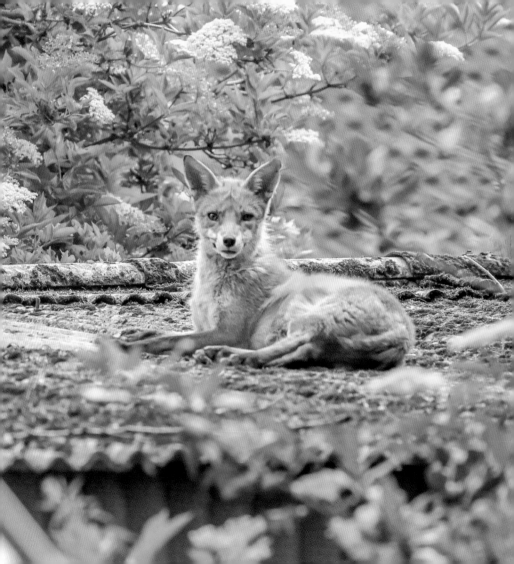

The urban fox and the rural fox

A fox is still just a fox, whether he is crossing your lawn in the town or your field in the country; to him there is no real distinction, life just goes on. The fox has always inhabited places where humans lived but because of the gradual change in the nature of the countryside and their natural caution, they kept a low profile.

The public in the 21st century perceives that it sees more foxes in the town, forgetting that few people in the pre-war years would have fed a fox, except perhaps fox hunts wishing to keep their numbers up. Today, most streets in any urban conurbation will have at least one person who is doing just that. In the past, foxes have generally not been considered as urban 'pets'. An hour looking through Facebook fox sites or similar, will make it obvious that there are very many urban foxes with human benefactors.

The intelligence of the fox has been his single most important feature, leading him to adapt to man-made changes in landscape/habitat and food sources. An extreme example of this adaptation was witnessed by journalist Andrew Woodcock on the 18th April 2016. He wrote in his piece for the Press Association, for whom he works: *'I was on the Number 12 heading from the Elephant & Castle towards Oxford Circus at around 07:50. I was on the top deck of the bus, heading up St George's Road, when I noticed a movement at floor level out of the corner of my eye. I looked down and it was a fox, walking along the aisle towards the front staircase. It had its head down low and was slinking along as if trying to avoid being noticed, but it didn't seem panicked or scared at all. Everyone noticed it and there were a lot of smirks and raised eyebrows and everyone looked to see what it would do next. It paused at the top of the steps as if waiting for the next stop. When we pulled up at the back*

of the Imperial War Museum, the driver came on the tannoy and said "OK guys, it looks like we've got a fox on the bus. We're just going to wait here a while and try to coax him off". As soon as the doors opened, the fox trotted down the stairs and hopped out onto the pavement. It may not have had an Oyster card with it, but it left a liquid donation on the top step, so I guess it can't have been quite as cool as it seemed ...'

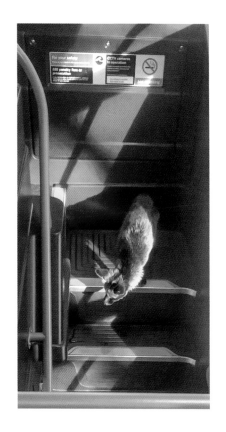

The fox learned to live comfortably alongside man, rather than fear him. Since before the turn of the 20th century, the railways and canals have provided cuts through every large city in the nation, a highway if you like for wildlife. Although always careful around humans, the fox made in-roads even then and would take the easy pickings offered by a carelessly closed back yard chicken coop or rabbit hutch. The war changed people's attitudes to self-sufficiency: suddenly everybody was a keen chicken keeper or vegetable grower.

However, as soon as it was over and supermarkets began to take over the provision of meat and vegetables two decades later, fewer people kept chickens or livestock and fox-proof garden security became a thing of the past.

Another game changer for the fox was the 1953 myxomatosis epidemic that quickly almost obliterated the 100 million British rabbit population. This could of course have been bad news for the fox too. However, the ever-adaptable fox switched to field voles and there was an added useful side effect; people no longer set traps for rabbits, which in turn meant foxes were safer in gardens and the countryside in general. Leg-hold 'Gin' traps, named from the original title 'Engine traps', actually became illegal in 1958. These brutal traps were designed to catch rats and rabbits, but they would have splintered the legs of countless foxes as well as domestic cats and dogs.

In medieval England the wolf was hunted to extinction because of the problems it caused to livestock; the nobility, having nothing better to hunt, took up the cry of 'view halloo' and have been hunting the fox ever since. Fox hunting, which originated in Britain in the 16th century, became popular amongst wealthy landowners and, in order to ensure there were enough foxes to hunt for eight or nine months of the year, thousands of foxes were imported from all over Europe and sold to hunts through London's Leadenhall Market. English hunters even exported fox hunting to the colonies and beyond.

At the time of writing, hunting with dogs is banned by law in England and Wales, but the Hunting Act 2004 and the similar ban in Scotland are riddled with loop-holes and most hunts appear to be continuing much as they were before Parliament passed the law. There are also moves by pro-hunt Government ministers to

The fox is the smallest member of the canine family so has traits in common with domestic dogs, coyotes and wolves. Unlike some of these however, the fox is not a pack animal.

overturn the ban. Polling from Ipsos MORI, conducted in 2015 on behalf of The League Against Cruel Sports, shows that 83% of people think fox hunting should remain illegal, one would hope that this will be the case and that if anything, the law should be strengthened.

The fox is the smallest member of the canine family so has traits in common with domestic dogs, coyotes and wolves. Unlike some of these however, the fox is not a pack animal. Grouping together only for the raising of cubs, the rest of the time they are solitary and hunt and sleep alone.

With their thick fur for warmth, it is not surprising to find that they are mainly nocturnal. The pelt can be found in many shades from russet brown to almost golden and they use their thick 'brush' tail for signalling and balance and even for warmth; it wraps around their body snugly when they sleep. Foxes have a vertical pupil in their eyes which gives them good sight in poor light. Like many nocturnal animals they have a *tapetum lucidum* which sits behind the retina and reflects light back through it. The photoreceptors in the back of the eye have an increased amount of light available to them and this helps with night vision.

Foxes also hunt with a very marked stalking and pouncing style. This leap and pounce technique even

works with prey under a metre or more of snow. Their acute hearing will pick up any movement below and they seem to relish the dive into the icy whiteness. In 2011, Jaroslav Červený and his 23-man team of wildlife biologists hypothesised that their research done in the Czech Republic suggested that the fox uses the magnetic field of the earth to help locate prey. They witnessed over 600 pouncing 'mouse' jumps and the foxes that consistently jumped to the north-east had a 73% kill rate. A jump in the opposite direction dropped the rate to 60%, whilst only 18% of pounces produced a kill in all other directions. It is hard to disprove or confirm that it was the earth's magnetic field that helped the foxes as it can hardly be switched off as it could be in a laboratory test. However other scientists who have studied this sort of thing in birds and cattle, think it a plausible conclusion. Sensitive whiskers on the nose, plus extras on the legs and the ability to 'taste' the air on their tongues also help to make for a very thorough hunter. Having made a kill, the fox uses its carnassial or shearing teeth to cut prey into edible bits rather than chewing.

The vertical pupil, their solitary hunting technique and their lithe physique gives them an even closer affinity to cats, including the ability to climb fences and walls. They often take refuge on rooftops and even sleep in trees. In February 2009, a couple in Ipswich, Suffolk were amazed to see that what they thought was a cat asleep in a tree turned out to be a fox, in fact, two foxes. They had noticed foxes in the garden but never up a tree, and thought perhaps they liked the spot as the branches were thick and it made for a wonderfully warm spot in which to relax in the daytime in the spring sunshine.

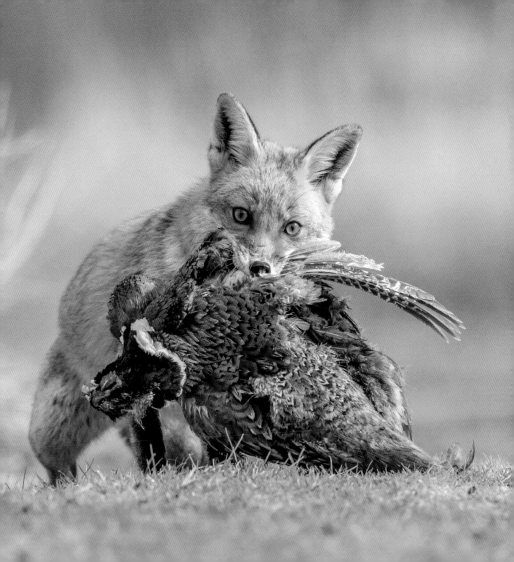

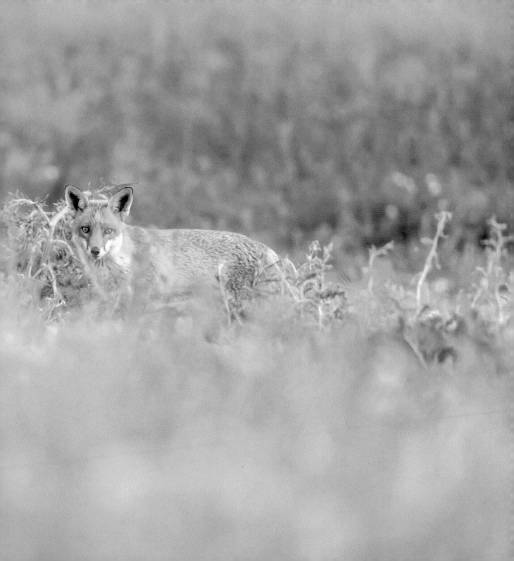

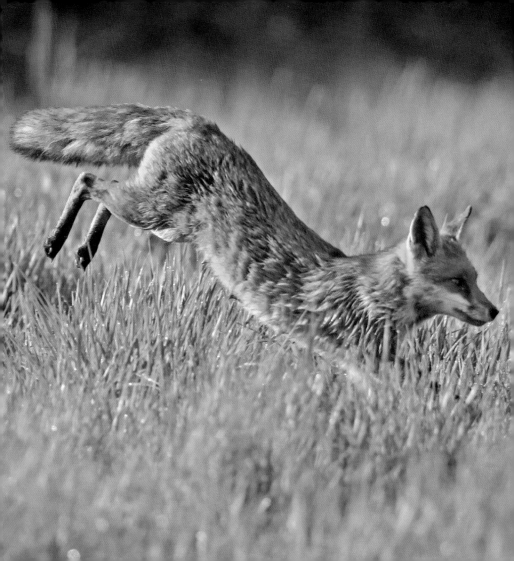

Sport or pest control

Excerpts from *The Mouse Stranglers*
by John Bryant

Excerpts from *The Mouse Stranglers* by John Bryant

Rural Foxes

Red Foxes are probably the most studied wild animals on the planet. In the UK, these controversial animals have been, or are still being, studied by scientists from the Universities of Bristol, Oxford, Aberdeen, Brighton and York. Professor Stephen Harris of Bristol University's School of Biological Sciences has spent almost fifty years studying this British indigenous species which is deeply ingrained in mythology - most of which exaggerates its cunning and even associates it with evil spirits.

As a child, I always hated the idea of people using packs of hounds to chase and kill animals for 'sport', but my interest was ignited when, as a new member of the RSPCA, I attended my first annual general meeting of the Society in London in the summer of 1970. There I learned from other members that the Masters of Fox Hounds Association, under their then chairman Lord Halifax, had successfully implemented a secret plan to infiltrate the RSPCA and thereby prevent the Society campaigning against fox hunting or any other form of hunting with dogs. A small group of us ordinary members formed a 'Reform Group' to counter the hunters, whose infiltration had been so successful in manipulating elections to the Society's ruling Council, that *Horse and Hound* magazine had confidently announced the name of the new Council chairman before he was even elected!

The situation prompted me to find out everything I could about foxes and fox hunting, and in fact

changed the entire course of my life. There was much to learn. Records show that in the mid-16th century, foxes were amongst a list of species declared to be 'pests' by an act of Parliament which enabled churchwardens to pay out bounties upon production of the dead creatures.

In Tudor times, foxes were driven into nets by dogs and clubbed to death for their poultry-killing crimes, but later this developed into a sport involving dogs chasing foxes for the entertainment of horse riders. Of course the hounds had to be trained to hunt and kill foxes, and terriers trained to attack foxes underground. The training methods were incredibly cruel and these days would result in public outrage, imprisonment and life-time bans on keeping animals for all those involved.

The 'father of modern fox hunting' was Hugo Meynell (1735 – 1808), Master of the Quorn Hunt in Leicestershire. Hounds were bred to have good pace, but more importantly high stamina, so that foxes could be pursued across open countryside and thereby provide a chase for horse riders. The natural instinct for a fox faced with danger is to sprint to its den and seek safety underground. To ensure that the fox remained above ground to be forced to run long distances for the entertainment of the mounted followers, 'earth-stoppers' were employed to go out at night while the foxes were foraging for food, and block up any known fox earth or badger sett. When hounds found a fox in the morning it would run from blocked den to blocked den until exhaustion delivered it into the teeth of the hounds and their superior weight and stamina. If a fox found an unblocked hole missed by the 'earth-stoppers', the hunters would send in terriers to either drive it out for further hunting or to keep it under attack until it could be dug out and killed. However, foxes were often

either 'given best' or even captured alive and returned to Hunt kennels to be hunted again another day.

When fox hunting began to achieve popularity in the 18th century, the fox population was not big enough to sustain hundreds of Hunts operating for eight months of the year. So up until the mid-1800s, thousands of foxes were imported from all over Europe and sold through London's Leadenhall Market to Hunt Masters for 'half a crown' each. These were then transported back to the particular Hunt's area where they were provided with artificial dens and food to encourage them to breed.

Despite large numbers of foxes being killed, populations stayed stable until the explosion of pheasant shooting in the Victorian age. In order to preserve as many pheasants as possible for the guns, gamekeepers shot, snared, trapped and poisoned any wild creature which might take game birds, particularly foxes. In some primary shooting areas, such as East Anglia foxes were virtually wiped out. This led to an uneasy relationship between some Fox Hunts and shooting estates, but in other areas, when Fox Hunts ran out of local foxes, gamekeepers earned perks by selling them their captured foxes instead of killing them.

The First World War led to the decline of gamekeeping and this resulted in fox populations increasing. Since the 1960s, the British fox population has been steady at an estimated 250,000. Research suggests that in a stable population at that level, in excess of 400,000 cubs will be born annually. Therefore out of the Springtime total population, 400,000 must die annually before the next annual breeding season – mostly very young cubs before they even leave their earth. Foxes, like domestic dogs, should be capable of living to 10 or 12 years of age, but eight out of ten foxes fail to reach two years of age due to high mortality of cubs,

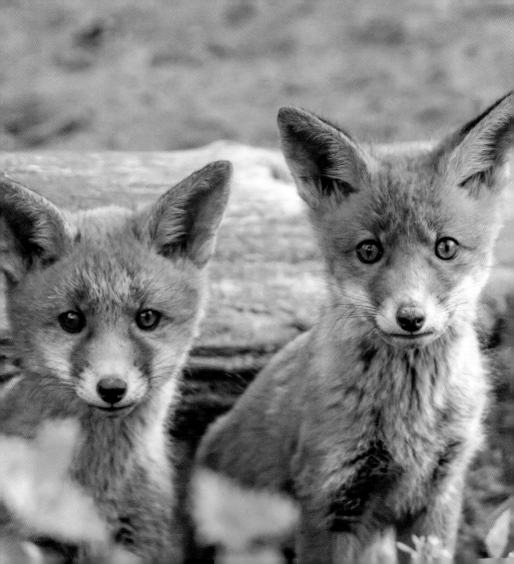

persecution in the countryside, traffic in the towns and diseases such as sarcoptic mange.

Fox hunting with hounds, of course, is not pest control. After all, if a group of rat catchers imported thousands of rats, transported them around the country, provided them with nesting areas and food to encourage breeding, all in order to set terriers on them for 'sport', no-one in their right mind would regard the practice as 'pest control'.

When Fox Hunting was invented by the aristocracy and major landowners they had the power to prevent their tenant farmers from killing local foxes. Thus, foxes were preserved for 'the chase' and provided with artificial 'earths' in small pieces of protected woodland called fox coverts (pronounced 'covers'). Later, when people began to question the preservation of an animal that was raiding their chicken houses, Hunts began to pay compensation to aggrieved farmers, both for lost stock and for the repair of fences and hedges damaged by scores of horses crashing around the countryside carrying the local gentry.

In 1976, the newly elected RSPCA Council, freed of hunt infiltration following a highly publicised Public Enquiry (The Sparrow Enquiry), announced for the first time in its history that it opposed all hunting of wild animals with dogs, thus uniting its policy with smaller groups such as the League Against Cruel Sports. The issue began to become political as public opinion against hunting hardened. The hunting lobby realised it had to start defending 'sport' as a way of controlling 'pests', 'managing wildlife', 'providing countryside employment', and 'a healthy country activity'. Farmers, however, began to feel confident in banning hunting on their land, and the League Against Cruel Sports began to offer legal support to landowners troubled by trespassing hunters.

Unfortunately for the hunting lobby, the pest control argument was easily countered by years of scientific research. In order to start reducing the population of animals like foxes, it would be necessary to kill around 70% of the population annually – otherwise the population would be fully restored in a single breeding season. 70% of the British fox population would be 175,000 animals. Britain's two hundred or so Fox Hunts only killed a maximum of 20,000 foxes per year between August and April. So Fox Hunts were only ever responsible for 5% of the number of foxes dying annually. Some pest control! The public exposure of artificial earths maintained by every Fox Hunt to ensure fox numbers remained high enough for hounds to find, chase and kill for two or three days a week from August to April, hardly fits in with the average person's concept of 'pest control'.

In 1991, Mike Huskisson, an undercover investigator for the League Against Cruel Sports, filmed the Quorn Hunt digging out a fox cub and releasing it alive for the hounds to savage to death. Leaders of the hunting lobby had always denied that such disgusting practices existed and so when the story broke in the national media, the public realised that if Britain's most prestigious Hunt was prepared to break the Masters of Foxhounds Association's rules, then all of Britain's 200 Fox Hunts were probably doing the same and possibly much worse. Public opinion hardened against all forms of hunting with dogs and remained firmly between 70 and 80 per cent, providing the Labour Party with the confidence to adopt a policy to outlaw hunting with dogs.

In 1997 following the election of a Labour government, Worcester MP Michael Foster drew first place in the ballot for Private Members' Bills and following consultation with his constituents, introduced a Bill to

outlaw the hunting of wild animals with dogs. His Bill was passed by the House of Commons at its second reading on 28th November by 411 votes to 151 – the largest majority for a disputed bill in Parliamentary history. The hunting lobby's friends in Parliament, through outrageous 'filibustering' managed to delay the Bill, and despite its popularity with the public and Labour back-benchers, it failed to reach the statute book until Labour's second term, in February 2005. But by the time the Hunting Act became the law of the land in England and Wales, Tony Blair had reneged on his previous written promise to vote for abolition and (as he has admitted in his autobiography) had sabotaged the final version for his new-found hunting friends amongst the 'Chipping Norton set' by introducing clauses and loopholes you could drive a pack of hounds through!

In 2003, facing the abolition of their bloodsports, in excess of 40,000 hunt members and supporters had publicly signed a declaration that they would defy any law which outlawed the hunting of wild animals with dogs. Blair's devious intervention eight years after the House of Commons had voted for a ban by a majority of 250 MPs, meant that the hunters could carry on hunting with very little chance of being prosecuted. When it became obvious that the Hunting Act would reach the statute book, the hunters dropped their threats of defying the law, and instead stated that they would switch to 'trail hunting' which they described as the 'simulated hunting of a wild animal.'

A small number of voluntary hunt monitors have attended Hunts all over England and Wales and have reported foxes frequently being chased, and sometimes killed by hounds, in exactly the same way as they were before the passage of the Hunting Act. Despite violent attacks on their vehicles and camera

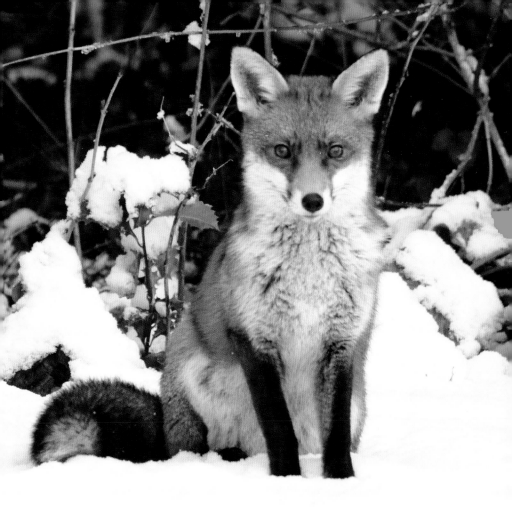

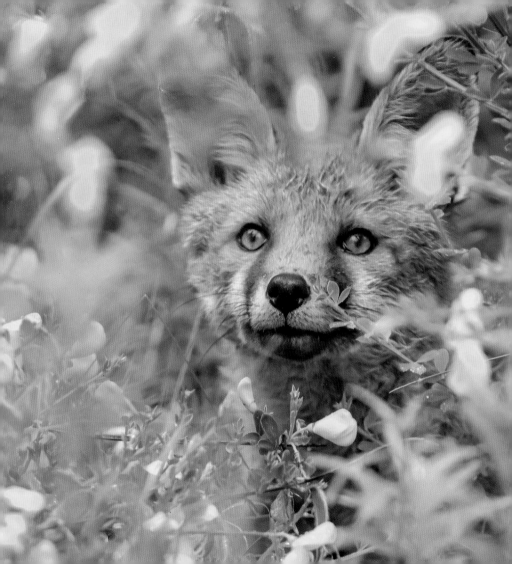

equipment, and despite experiencing outrageous verbal and physical assaults, these brave monitors have managed to record sufficient evidence to achieve a tiny handful of prosecutions against Hunts, but the vast majority of their members know that the Act is so full of loopholes and 'exemptions' that the chances of being dragged into court are not worth worrying about.

The police have used the Hunting Act to catch and prosecute hundreds of trespassing hare coursers and poachers, because the law is very straightforward on the issue of hare-coursing. But the police and Crown Prosecution Service have studiously avoided investigating Fox and Deer Hunting. Since the election of the coalition government in 2010, David Cameron has appointed two hunters as police ministers and this may well have influenced the interest by the police. Despite one landmark successful prosecution of the Heythrop Hunt by the RSPCA, the evidence gathered by hunt monitors shows that Fox Hunts are still chasing and killing foxes but can easily escape prosecution by claiming that it was an *accident that occurred when a fox jumped up while our hounds were following a trail laid by hunt staff'.*

The Hunting Act demands that for a successful prosecution it has to be proved that *'a person was engaged or participating in the hunting of a wild mammal with a dog'* – which means there has to be evidence that the person 'intended' the dogs to hunt a wild animal. If the hunter claims to have intended his hounds to follow an artificial trail, backed up by scores of members of the Hunt, it is extremely difficult to prove otherwise, and the hunter gets the benefit of the doubt. I was a member of the legal team of the Campaign for the Protection of the Hunted Animals for Michael Foster's original Bill, when we drafted the offence to be: 'A person causing or permitting a dog to hunt a

wild mammal' with a tightly drafted definition of 'hunting' to ensure it would not result in prosecution of people exercising their family pet or working dog if it scampered after a squirrel for instance while being exercised off the lead.

There is no doubt that unless a 'recklessness' clause is added to the Hunting Act to deter hunters from releasing packs of hunting dogs in woods, crops or cover where they have for decades found and hunted foxes, deer or hares, then the intention of Parliament and the vast majority of the public, to prevent wild animals from being hounded to a savage death by dogs will have been thwarted for the amusement of a minority.

The fact is that the hunting of foxes, deer, hares and mink are 'sports' and always have been, as was otter hunting until 1977 when otters became totally protected to prevent them becoming extinct. As for fox hunting, all research by government scientists, as well as that by the Universities of Bristol, Oxford, York and Aberdeen agree that the impact of foxes on any branch of agriculture, in the words of the Ministry of Agriculture, Fisheries and Food since the 1970s and unchanged by DEFRA , is 'nationally insignificant.'

Commercial poultry farms which rear poultry for eggs or meat keep their birds in massive sheds, and even those which are free-range, protect their birds from fox predation with high and/or electric fences. But even in the days before intensive farming, the British Field Sports Society (the forerunner of the Countryside Alliance) stated in its leaflet written by Master of Fox Hounds DWE Brock, and revised in 1973: *"The staple diet of a fox is not, as so many people apparently imagine, hens and ducks. Indeed it is probably true to say that not 5% of all the foxes in Christendom ever taste domestic poultry at all. The majority*

of foxes feed largely upon beetles, frogs, rabbits and wild birds; carrion does not come amiss to their diet, while they are the biggest destroyers of rats and mice in the world, far exceeding the domestic cat in this useful art."

The Countryside Alliance early in 2014 claimed that the Hunting Act should be weakened (as if it was not weak enough already) to allow sheep farmers to call in full packs of hounds to flush out foxes to be shot. The Act limits the number of dogs that can be used for such 'flushing out' to two, but the Alliance said that Welsh hill farmers were experiencing high fox predation on their lambs and that using full packs of hounds would be more efficient and more humane!

The issue of fox predation on lambs has been the subject of much research in all parts of the UK and all studies have revealed that the impact of foxes on lambs is tiny.

A report from MAFF's Exeter Veterinary Investigation Officer, November 1977, stated:

"Mis-mothering and secondary starvation are major causes of losses. Breakdown of the natural ewe-bond occurs more frequently in ewes underfed in late pregnancy and increases in inclement weather. Mis-mothered lambs survive for 1-3 days, depending on the weather and body reserves. Weak lambs are easy prey for predators, but post mortem examinations reveal that many lambs showing signs of fox predation were in fact dead prior to attack, and the fox had been scavenging rather than hunting."

More up-to-date confirmation comes from Professor Stephen Harris in the launch of Fox UK by *BBC Wildlife* magazine in January 2006: *"Over the past twenty years, many studies have looked at the impact of foxes on lambs. All this research agrees: lamb losses are low, and greatest*

on those farms where husbandry is poor. To put this in economic terms, in the late 1990s sheep producers lost up to 4 million lambs each year, at an annual cost of £120 million. Deaths due to misadventure (accidents) and all predation (not just foxes) accounted for just 5 per cent of these losses."

Incidentally, 'predators' include dogs, and the 8th Duke of Beaufort, Master of Fox Hounds, wrote in his book *Hunting*, as long ago as 1901. *"In almost every case where a fox is found eating a lamb, it has been killed by a dog, and generally a sheep dog; more often than not by the lamb's own shepherd's dog."* He added, *"I do not say foxes never kill lambs but I say that such an occurrence is very rare."*

The cost of predation by foxes on farm stock has been estimated at £12 million per annum, which sounds a lot. But in his Fox UK booklet, Professor Harris points out that the

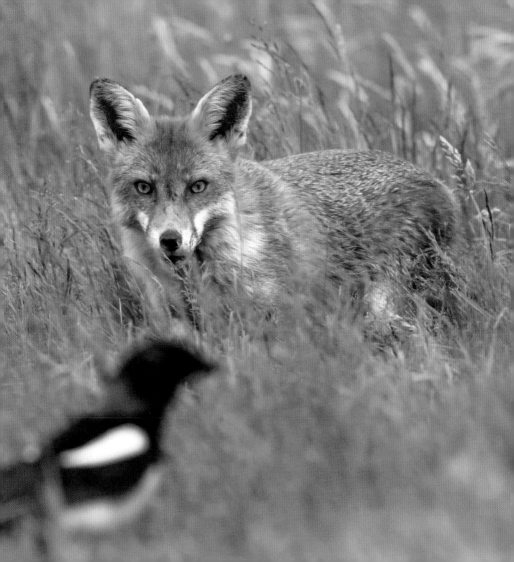

biggest cause of agricultural damage is rabbits, and in lowland areas rabbits comprise 45 to 70 per cent of the diet of foxes. One study estimated that each fox was worth between £150 and £900 in increased revenue to farmers due to its predation of rabbits. So it is likely that as far as farming is concerned, foxes are economically neutral.

The worst form of fox hunting with dogs is 'terrier-work' where various breeds of terrier are sent underground to attack foxes. The battle is totally out of control of the owners of these dogs, and both foxes and dogs are often badly injured before they can be dug out. When I was wildlife officer for the League Against Cruel Sports, our undercover investigators came back with video films made by the terrier-men themselves which were disturbingly horrific – with terrified fox cubs held up to the cameras by grinning thugs, and then given to the dogs to savage to death.

The Hunting Act banned the use of dogs to attack foxes underground, but Blair and his ministers insisted on a clause which allows this brutal form of underground dog-fighting to continue, provided it is undertaken *'for the purpose of preventing or reducing serious damage to game birds or wild birds which a person is keeping or preserving for the purpose of being shot.'*

This sickening and savage bloodsport is only permitted to continue in the name of another disgusting and sadistic bloodsport – the massacre of factory-farmed pheasants. The law does not even require proof that the foxes have been 'causing serious damage' to game or wild birds. The result is that the terrier-men who have always accompanied Fox Hunts to use their dogs to punish foxes which have escaped underground, are still involved with the same Hunts which are supposed to be banned from hunting foxes and which claim to be hunting an artificial 'trail'.

When the hounds 'accidentally' put up a fox and force it to seek safety by 'going to earth', the terrier-men rush forward to get their kicks by sending their dogs underground to either flush out, or fight the fox. The only changes for terrier-men from 'pre-ban' days, is firstly that they can only send one terrier underground at a time, and secondly, if their activity is challenged they carry a card signed by the local landowner to say they have permission to send their terrier underground to attack foxes to 'preserve his pheasants' even when the land is not even being used for commercial shooting.

In my twelve years working professionally for the League Against Cruel Sports, I learned that when it comes to wildlife and animal protection legislation, the law firstly criminalises an abuse and then provides numerous opportunities for some privileged group of people to persist with that abuse.

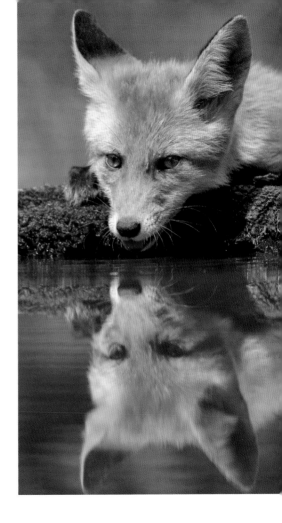

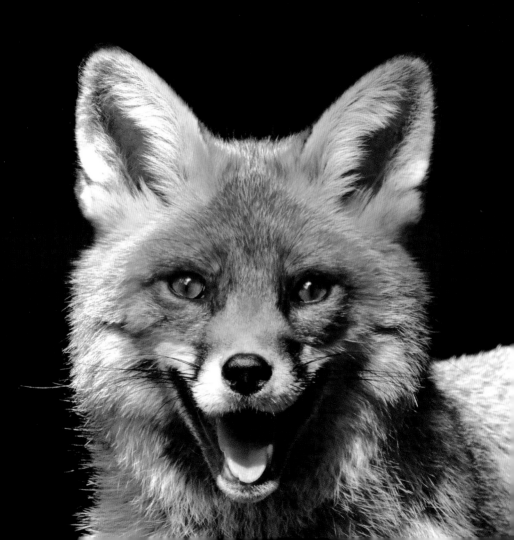

Urban Foxes

What about the 'pest' status of the UK's 33,000 urban foxes living in our towns and cities? In 1998 I became a professional urban 'pest controller', using humane, non-lethal deterrence techniques to deter nuisance foxes and to provide advice to urban dwellers on how to adapt their gardens to make them less hospitable to foxes or other unwanted wildlife.

Bristol University has been conducting research into urban foxes for almost five decades. Professor Stephen Harris and his team have produced several books and reams of scientific papers. His classic book, *Urban Foxes* first published in 1986 has been reprinted in 1988, 1992, 1994 and 2001. There is not much we don't know about British urban foxes which have been settling in our cities since the 1930s. Of all the wild creatures which turn up in human habitation around the world, we in

Britain are lucky that ours is only the same size as a large domestic cat, weighs the same as a Jack Russell terrier, is a scavenger more than a predator, and the wildlife it does hunt are mostly rats, mice and pigeons, creatures which most urban folk are not too keen on.

Inevitably, with more than 30,000 urban foxes living hand in glove with human beings, some of whom are sympathetic to these wild neighbours to the extent of feeding them, there are bound to be a few incidents when a fox enters a house through an open door or open window, and someone gets nipped. I've known of cases where people have come home from work to find a fox asleep on their bed, and have then screamed and grabbed a broom to chase the fox out. The fox panics and charges around the house looking for an escape route, knocking over ornaments, jumping onto window sills and generally causing chaos. The proper way to evict a fox from a house is firstly to

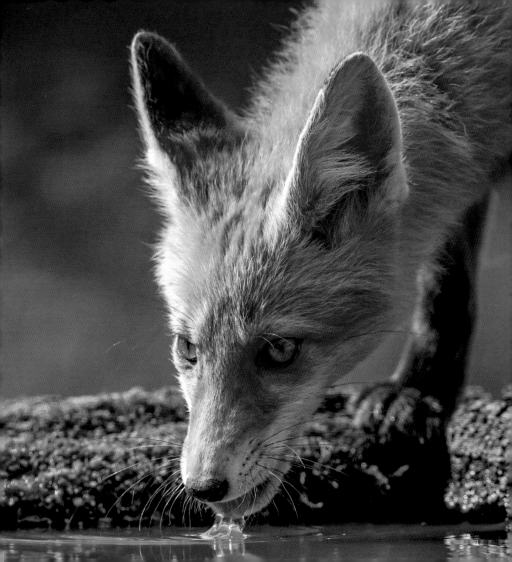

keep calm and quietly create an easy single route to the nearest open door to the outside by closing off other rooms. Then speaking firmly, but not loudly, shepherd the fox out of the room making sure there is no-one in its way.

Local authorities all over London had operated permanent fox culls for four decades up until, and even into, the 1980s. I have never managed to find statistics on how many tens of thousands of urban foxes were killed in London during those forty years or how many millions of pounds it cost taxpayers. The culls were abandoned in the 1980s for several reasons. Firstly, there were more foxes than when the culls started. Secondly, polls revealed that the majority of Londoners were either tolerant or supportive of urban foxes, and thirdly, the foxes were not considered to represent a danger or health risk to the public. The last London Borough Council to abandon culling was Bromley in south London in 1989, having found that the costs of culling using cage traps, shooting and terriers were around £1,500 per fox (say £4,000 at 2014 prices) and yet the fox population remained the same year in and year out. The London Borough of Lewisham had hired a team of terrier-men to kill foxes, but again found that numbers did not fall, and the neighbouring Councils of Southwark and Lambeth had a policy of non-interference with foxes, and their fox population also hardly varied from year to year.

Trevor Williams, Director of the Fox Project charity which he founded in Plumstead, south east London in 1991, has been providing advice on humane fox deterrence, countering myths and ignorance, spreading knowledge, and providing hospital care for sick and injured foxes. This work, together with decades of research by Bristol University, has resulted in a more sensible attitude to urban foxes – particularly that 'culling urban foxes' is pointless,

as reflected in the policy of virtually all local authorities as well as the government's Department of Environment, Food and Rural Affairs (DEFRA).

We do not even have a rabies issue in the UK as, although endemic in Britain in the 19th century, the last bout of rabies in Britain began in 1918 in Plymouth and was caused by servicemen returning from the European war zone in 1918 with infected dogs. The outbreak was eliminated in 1922 after there had been confirmed cases in 312 dogs and a handful of cases in cattle, sheep, pigs and a horse. Rabies has never been found in UK foxes – even when it was endemic. It is worth noting that the strain of rabies that affects foxes is different from the strain that is suffered by dogs. (Stephen Harris and Phil Baker, *Urban Foxes*, Whittet Books. 2001 edition).

There are periodically 'urban fox attack' scares in the media but these are often found to be untrue or grossly exaggerated. I personally know of two such cases of 'fox attacks' on children which made local and national newspapers. One 'fox' later turned out to be the family's German Shepherd which had previously attacked one of the family's other children – prompting visits from social services. In another case a fox was alleged to have entered a bedroom and killed a kitten – the pet of a seven year-old boy. The day after the story appeared in the press, the boy's grandfather rang me to say that his grandson had told him that the family's dog had killed the kitten, and his mother had told him to say that it was a fox.

Any incident involving an urban fox is seized on by newspapers and not only by the red-top tabloids. In 2003, with Labour in power, a ban on hunting was being hotly debated in the House of Commons and pro-hunting MPs were not slow to

highlight urban fox 'crimes' implying that because urban foxes were not hunted by packs of hounds they were not being properly controlled. Pro-hunt newspapers played their part, for instance, the London Evening Standard and the Daily Mail both reported that there were 80,000 foxes in London - a totally nonsensical figure and more than twice the number of urban foxes in the whole of Britain!

The London Fox population, taking the M25 as a boundary, is only between five and ten thousand adults. In Parliament's hunting debate, Conservative hunting fanatic James Gray, MP for North Wiltshire, stated that the London Borough of Wandsworth had appointed an organisation called Wildlife Management Ltd, that had trapped 2,717 foxes in the borough in the past year and said that the company was approved by DEFRA. In response, DEFRA Minister Alun Michael stated that Wandsworth

Borough Council had confirmed in writing that it had no contract with Wildlife Management Ltd and that DEFRA had given no approval to the company. The Minister quoted me as saying that the company's figures were ridiculous and that based on the Fox Project's knowledge of the Borough, there were no more than 200 adult foxes in the whole of Wandsworth.

Mr Gray had to admit that the figures he quoted were from the pest control company itself and that he had not contacted the Council for verification. Still desperately back-pedalling, Mr Gray asked the Minister what he thought of the Evening Standard's report of the previous day, that 9,000 foxes had been killed in London in the past six months. With a maximum of 10,000 Foxes within the whole M25 boundary, such a kill-rate in only six months would literally empty London of foxes – something that had not been achieved in 40 years of sustained culling, let alone

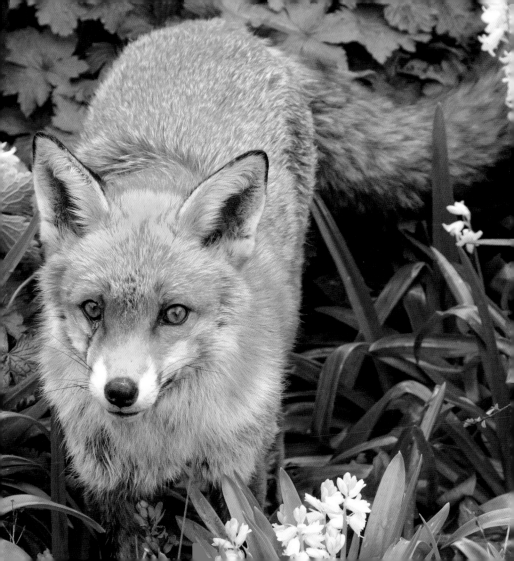

six months. Mr Michael politely suggested to Mr Gray that he should refrain from presenting unverified information to parliament.

The debate shows just how far people are prepared to wander from the facts to argue that their view is the right one. This applies to both camps in the pro and anti-fox campaigns. There are pro-fox people who have argued that foxes never attack cats, instead of accepting the fact that although it is rare, and that in most cases foxes and cats coexist peacefully, there is always the odd exception. It is pointless to claim a fox would never bite a child, instead of accepting, as the government states, that such events are 'extremely rare'.

The aforementioned exchange in the House of Commons also illustrates the folly of believing 'facts' stated by people with vested interests. Similarly, in public debates about fox hunting, especially in radio 'phone-ins', there is usually someone who claims to be a sheep farmer and who insists, "I've seen a fox kill a dozen of my lambs" (as if any farmer would simply stand by and watch his stock being killed). In the entire history of such arguments, not one clip of film has ever been produced showing a fox killing a lamb. On the contrary, wildlife film-makers have recorded foxes trotting through fields of new-born lambs with both lambs and ewes showing no concern. There is no doubt that foxes scavenge after-birth and will take a dead lamb, or even one dying and abandoned by its mother. So for the truth we have to rely on science and postmortem results – experts who don't set out with closed minds.

Surveys show that the vast majority of urban people were either tolerant or admirers of urban foxes despite raids on bin-bags, digging holes in lawns, waking people with their screams, digging dens under sheds and fouling on doorsteps. There was

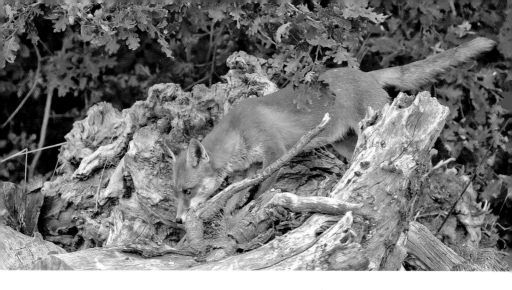

a major scare over 'fox attacks' in the summer of 2010, with weeks of headlines in the media and this event dramatically changed public opinion. Local Councils and pest controllers, including me, were deluged with calls from urban folk, particularly in London, demanding action against their local foxes. Councils sent out leaflets explaining that culling had been a proven failure, but many pest controllers made a lot of money out of cage trapping and shooting foxes – despite the fact that they all knew full well that killing foxes merely created a vacancy for neighbouring foxes to move into. One major pest control company was charging between £800 and £1,000 to catch and kill a family of foxes, but was not telling clients that the killed foxes would soon be replaced.

In November 2012, I was invited to speak at an Urban Fox Conference in Essex organised by Gary Williams

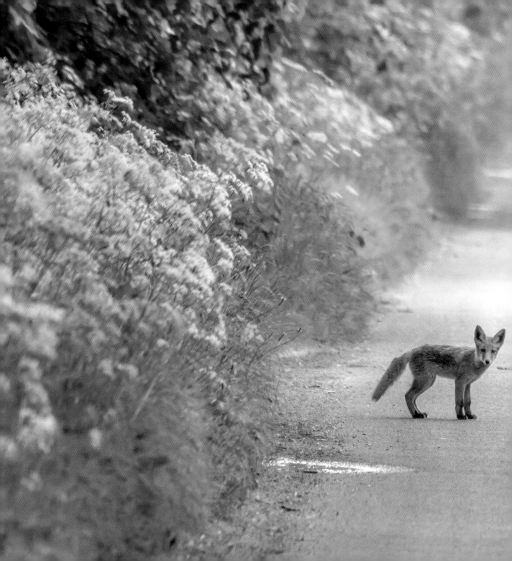

Whether for 'pest control' or 'sport' or even a combination of the two, killing is pointless.

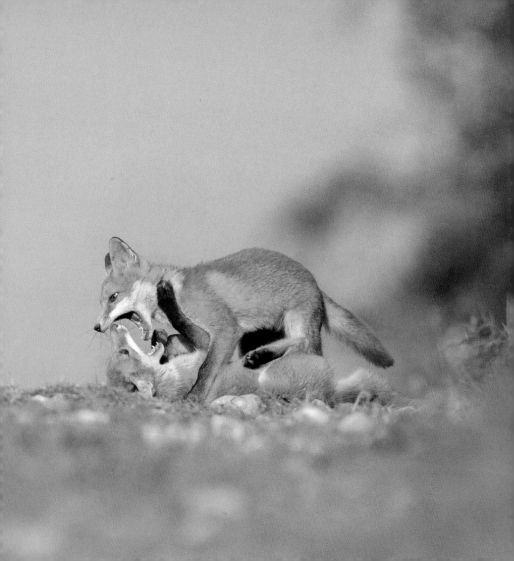

and Louise Summers of 'Urban Wildlife.' The delegates were pest controllers and other interested parties, including Steve Barron who had been involved in the 2010 case, Rodney Calvert of Natural England, Tilly Stephens from the Food and Environment Research Agency and Barry Kauffman-Wright, a retired wildlife crime officer. I was relieved to find that everyone recognised that 'culling' foxes as a method of population control was pointless, but some thought that it was acceptable to cull individual foxes which exhibit 'abnormal behaviour' such as snatching packed lunches off children in playgrounds or entering houses and running off down the garden with a pair of trainers.

In my talk I disputed whether these 'crimes' justify lethal action. In a community where probably every fox is fed by at least one or two people and where other people encourage them into their gardens to film them, I think entering houses cannot be described as 'abnormal behaviour'. A few decades ago it would have been considered abnormal to see a fox out in daylight, but with many generations of foxes born and raised in an environment where human beings are the most common form of life they see, I think that for an intelligent and highly adaptable animal like a fox, it would be 'abnormal' if it displayed the sort of apprehension and nervousness we might expect of a rural fox.

At the meeting I suggested that any pest controller asked to kill a fox, should be duty-bound to inform his client that 'territories made vacant by culling resident foxes are rapidly colonised by new individuals' as included in DEFRA's policy statement below. The Department of Environment, Food and Rural Affairs has maintained this Urban Fox Policy as determined by scientific evidence, despite the fact that the Secretary of State and the Prime Minister both support the return of fox hunting

for sport, and in the case of badgers don't display much respect for scientific opinion.

This is the DEFRA policy issued in the aftermath of the 2010 'fox attack'.

'Recent events have heightened public concern about urban foxes, however, attacks of this kind are extremely rare and we have no records of any other such attacks in recent years. In light of this, we have no plans to carry out a government-led cull of foxes.

Defra's general policy is that individuals should be free to manage wildlife within the law. In the first instance dealing with foxes is the responsibility of the owner or occupier of the property where the problem occurs, but local authorities do have powers to take action where they feel it is appropriate.

Previous attempts to kill urban foxes to achieve a sustained population reduction have not been successful in the long-term because of the mobility of foxes and their ability to produce offspring in large numbers; territories made vacant by culling resident foxes are rapidly colonised by new individuals.

The most effective strategies to resolve fox problems have primarily relied on non-lethal methods, focusing on preventative and deterrent strategies.'

Rural foxes are the same as urban foxes. If killing urban foxes fails to provide a sustained population reduction because vacant territories are rapidly colonised by new foxes, then the same must happen in the countryside. Whether for 'pest control' or 'sport' or even a combination of the two, killing is pointless.

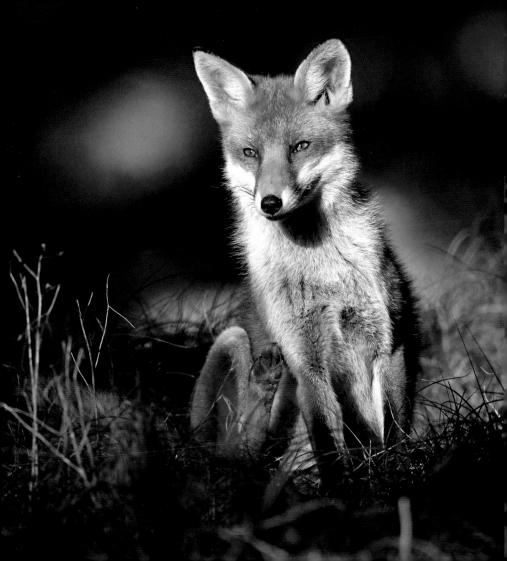

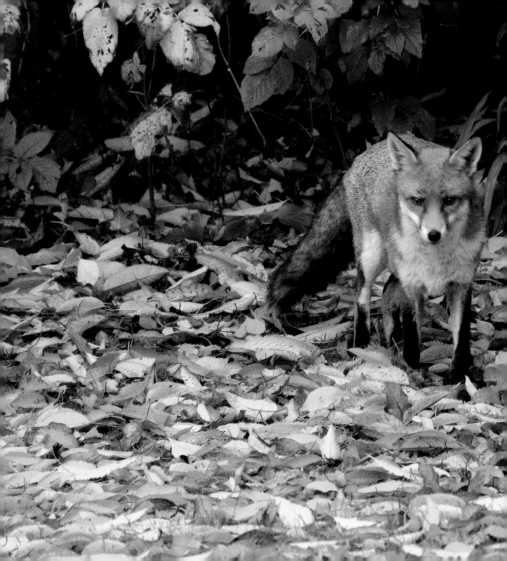

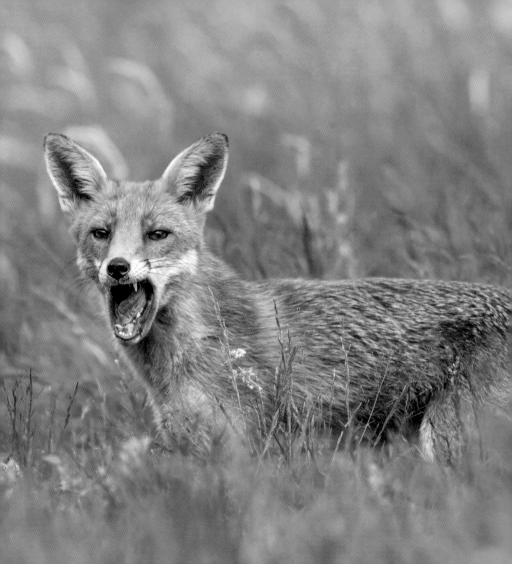

The fox worldwide

Worldwide, there are 37 mammals listed as having 'fox' in their name, whereas actually only those of the genus *Vulpes* are considered true foxes. Antarctica is the only continent without foxes. Males are called dogs, tods or reynards, with females known as vixens. Offspring are cubs, pups or kits, whilst the collective terms are skulk, leash or earth.

The Red Fox *(Vulpes vulpes)* is the most widespread and the one that most people in the UK would know and recognise. It is found in the entirety of the Northern Hemisphere, the Arctic Circle to North Africa, North America and Eurasia. As the name suggests the coat is a wonderfully warm red and the tail, which is large and bushy, is often tipped with white.

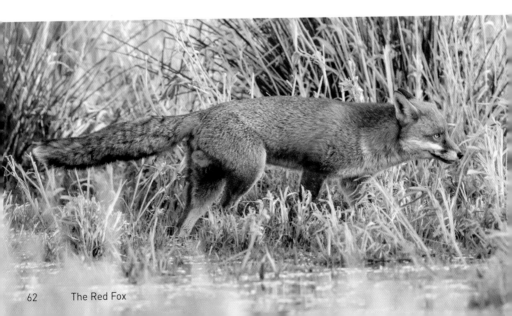

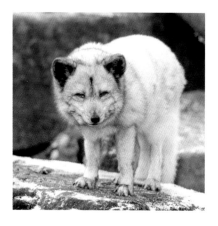

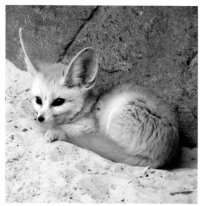

The Arctic Fox (*Vulpes lagopus*) has several other names: white fox, polar fox and snow fox. Its deep, thick coat or pelage changes with the seasons, from a summer brown to a winter white, thus ensuring the most perfect of camouflages in the snow. The coat is also a lighter weight in the summer than the winter. Its ears are close and small to minimise heat loss. The latin name (hare foot) comes from the fact that they have thick fur on their paws to conserve heat and prevent their pads from freezing.

The ears of the smallest of the true foxes, the **Fennec Fox (*Vulpes zerda*)** who lives in the Sahara desert in North Africa, are enormous. This helps to keep them cool in high temperatures. It has a short, fluffy coat and adapted kidney functions to help with life in the blistering heat. It also has thick, fur-covered soles on its paws to aid moving on sand and to protect the pads from burning. The tail is long, slim and black tipped.

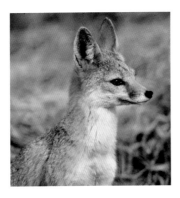 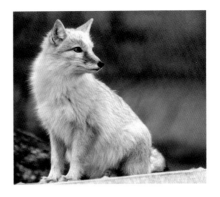

Much more like a scaled-down, greyer version of our well known red fox, the **Kit Fox** *(Vulpes macrotis)* is slight of stature, with a large head and very large, wide set ears and a long bushy tail with a black tip, which it carries straight out behind. It has fur on its feet for traction in sand and protection from heat. Sandy to grey in colour with a back slightly darker than the rest, it mainly inhabits the deserts of the Southwestern United States and northern and central Mexico. Like the Swift Fox, it can run at up to 25mph for short bursts.

The **Corsac Fox** *(Vulpes corsac)* gets its name from the Russian term, 'korsák'. It can be found in the steppes and deserts and semi-deserts of Central Asia, including Mongolia and northeast China. It is a medium size fox, sandy yellow in colour, with a coat that becomes thicker and silkier in winter. The tail is slim and there is a darker stripe of fur running down its back.

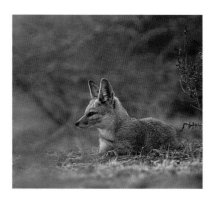

Tibetan Sand Foxes *(Vulpes ferrilata)* live in high altitudes on the Tibetan Plateau, straddling Nepal, China, Sikkim and Bhutan. They are small and close set with a very distinctive, long, narrow nose and small eyes set wider apart than the red fox. Their compact ears are also set wide apart. The top half of the body and legs are red, whilst the sides and top part of the tail are grey, the tip is white.

Also known as the Indian Fox, the **Bengal Fox *(Vulpes bengalensis)*** is, as the name suggests, the fox found on the Indian subcontinent. Generally small, the Bengal Fox shows a variety of coat colours across the seasons and areas where it lives. The predominant colours are grey to pale brown with a black tipped bushy tail.

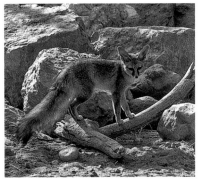

Worldwide, there are thirty seven mammals listed as having 'fox' in their name, actually only those of the genus *Vulpes* are considered true foxes.

Blanford's Fox *(Vulpes cana)* is known under at least nine other names, some of which are already in use (all followed by 'fox' - Afghan, royal, dog, hoary, steppe black, king cliff and Baluchistan). Found in areas of Afghanistan, Egypt, Turkestan, northeast Iran, southwest Pakistan, and Israel, it has been spotted in many regions in these areas. Although all semi-arid landscapes, the Blanford's Fox does not have fur on its paws and whilst it is agreed by most commentators that it has cat-like claws, whether they are semi-retractable or not is unconfirmed.

What is confirmed however is that they are by far the most agile of the true foxes, using their sharp claws for added grip when bounding up a cliff face. It has the usual large ears of the dessert dweller and a light, sandy coloured coat, with white on the underneath and a black stripe running down the back. The tail tip is most often black.

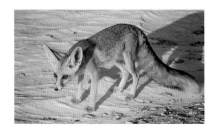

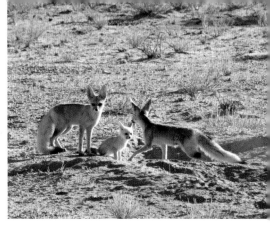

The German naturalist Eduard Rüppell gave his name to **Rüppell's Fox** *(Vulpes rueppellii)*. Confusingly, it is sometimes known as the sand fox, a term also used for the Tibetan Sand Fox and the Corsac Fox. Its coat is a soft, sandy colour with many white hairs. These go to clear white on the belly, and, unusually, on the tip of the tail too. The warm red of the head gives way to white patches under the eyes and very long whiskers. It is mainly found across North Africa, south of the Atlas Mountains from Morocco to Egypt. Like the Fennec Fox, it has large ears and fur on the soles of its paws to help with agile movement on sand, and as insulation against the heat.

Another semi-desert dweller is the small **Cape Fox** *(Vulpes charma)*, also known as the cama or silver-backed fox. Found mainly in the grassland of South Africa, it can have black or silver fur on the back with a sandy colour on belly, legs and head. The coat is almost double with a layer of black 'guard' hairs that are silver at the base, thus the coat has an almost silvery sheen to it. The ears, unsurprisingly, are large. The tail is full and appears dark from a distance, the tip black.

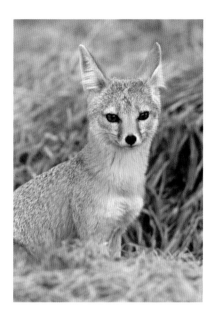

The **Pale Fox *(Vulpes pallida)*** is found on a band across central northern Africa called the African Sahel. Little is known about it because it is well camouflaged and hard to find in its inaccessible environment. It is of the huge eared, sandy coloured, black tipped tail, desert dwelling type, with short slim legs and a narrow nose. There are five sub-species: *Vulpes pallida pallida*, *Vulpes pallida cyrenaica*, *Vulpes pallida edwardsi*, *Vulpes pallida harterti*, *Vulpes pallida oertzeni*, which is of itself unusual bearing in mind how little is known of it.

Finally, the **Swift Fox *(Vulpes velox)*** (right) is one of the handsomest of the true foxes, with a coat of orange hues on its sides and legs and an area of silvery grey across the back. The tail is black tipped and there are black areas on either side of the nose. It lives mainly in grasslands in western North America from Montana to Texas. It can also be found in some parts of Canada where it has been reintroduced following extinction. A very close relative of the Kit fox, some academics have them both as hybrid sub-species, Swift Fox as *V. velox velox*, and the Kit Fox as *V. velox macrotis*. Like the Kit Fox, the Swift Fox has a short burst speed of up to 25mph.

The fox worldwide

	Length	tail length
Arctic fox (male)	46 – 68cm	30cm
Arctic fox (female)	41 – 55cm	30cm
Bengal fox	46cm	25cm
Blanfords fox	42cm	28 – 30cm
Cape fox (male)	average 55.4cm	average 34.8cm
Cape fox (female)	average 55.3cm	average 33.8cm
Corsac fox	45 – 65cm	19 – 35cm
Fennec fox	24 – 41cm	18 – 31cm
Kit fox	38 – 52 cm	22 – 32cm
Pale fox	38 – 45 cm	–
Red fox (male)	67 – 72cm	40cm
Red fox (female)	62 – 67cm	40cm
Rüppell's fox (male)	40 – 52cm	29 – 37cm
Rüppell's fox (female)	34 – 49cm	29 – 37cm
Swift fox	31cm incuding tail	–
Tibetan sand fox	60 – 70cm	29 – 40cm

This table of size is not definitive but is just an illustration for comparison purposes, all foxes, like all humans are individual for size.

eight at shoulder	ear size if known	weight
25 – 30cm	–	3.2 – 9.4 kg
25 – 30cm	–	1.4 – 3.2 kg
–	–	2.3 – 4.1 kg
30cm	–	0.9 – 1.5 kg
28 – 33cm	–	average 2.8 kg
28 – 33cm	–	average 2.5 kg
–	–	1.6 – 3.2 kg
20.3cm	10 – 15cm	1 – 2 kg
–	7.1 – 9.5cm	1.5 – 3 kg
–	–	2 – 3.6 kg
30 – 50 cm	7.7 – 12.5cm	6 – 7 kg
–	–	5 – 6 kg
–	–	1.1 – 2.3 kg
–	8 – 11cm	1.1 – 1.8 kg
30cm	–	2.2 – 3.1 kg
–	–	4 – 5.5 kg

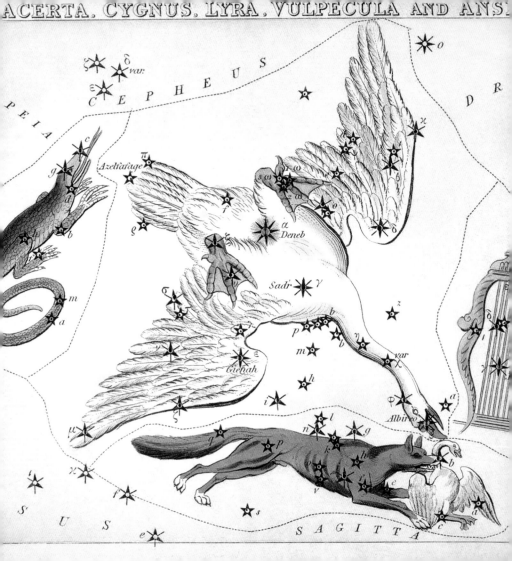

Myths and legends

Oral tradition has passed down many tales of the 'wily, sly and cunning' personality of the fox. A medieval storyteller would have described the nature of a fox in exactly the way we would today. Stories across the world use these clever epithets, and the animal's natural adaptability in changing environments and circumstance is a common theme.

Aesop famously depicted a fox in his moral tale 'The Fox and the Grapes'. The fox fails to reach a bunch of grapes which are high up in a tree, and parts with the line "I'm sure the grapes are sour," scorning those which are beyond his reach.

One version of another ancient Greek myth involving a fox, concerns the dog Lailaps (also known as Laelaps). A gift from Zeus, Lailaps eventually found his way to, amongst others, Kephalos. Lailaps was magically always destined to catch his prey and was used by Kephalos to hunt the Teumessian Fox, which was decimating the countryside of Thebes. The fox however, was destined never to be caught and this proved an issue for Zeus; the uncatchable being chased by the unfailing catcher. Zeus solved the problem by setting them in the sky as the constellation Canis Major and Minor, where the situation could be played out forever, for all to see. N.B. there are many versions of the Canis Major and Minor myth, this is just one of them!

The Canis' are not the only constellation in the night sky named after a fox, there is an indistinct constellation in the northern sky called *Vulpecula*, Latin for 'little fox'. Discovered originally in the 17th century and known then as *Vulpecula et Anser* 'the little fox and the goose' it has both gained and then lost again 'the goose' in the title and is today just known simply as 'the fox'.

In Finnish legend, the name for the northern lights is 'revontulet', from

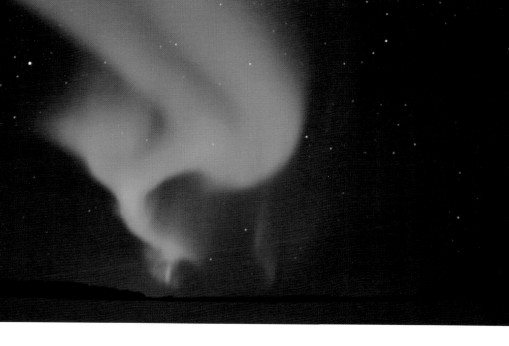

the Finnish for fox - 'revon'.

The ancient Finnish legend says that the amazing wonder of the northern lights is created by an arctic fox streaking to the north and touching the mountain peaks with its fur. The sparks from this 'touch and pass' are what causes the northern lights as we see them. Different versions explain the lights as the fox tossing snow to the sky with its tail.

In Finnish moral tales, the fox always outwits the evil wolf and the much stronger bear, with intelligence overcoming maliciousness or force.

The Irish for fox is *sionnach* and it is thought that they were originally brought to Ireland by Norsemen and

were in fact their dogs. There is one definition of the word shenanigans (tricks or mischief being undertaken) that suggests it is from the Irish term sionnachuighim, meaning 'I play the fox'.

To all the Celts and many other groups around the world, the fox, with its fiery red brush tail blazing behind it, symbolised and required acts of passion or mere playfulness. If a fox crossed your path, either in dreams or in life, you should take it as a sign that you follow your passions rather than the 'safe path'.

The Lindow man, a body found in 1984, preserved in a bog for over 2,000 years, had a fox fur amulet on his arm and some academics have suggested that he was killed in a druid ritual. The Celtic druids thought the abilities of the fox admirable, particularly that 'melt away to nowhere' skill for which they are well known.

Interestingly the Celts believed that foxes carried a magic pearl and were shape-shifters, not unlike the Kitsune *hoshi no tama* in Japan. (See Kitsune later in this section.) It is interesting to consider if the two stories are linked, and if so, how?

The wonderful adaptabilities of the fox are often admired across different societies. One man's clever is another man's cunning - perhaps the perceived cunning was a result of the fox laying false trails to evade its hunter. Dogon mythology (from the central plateau region of Mali, West Africa) features a pale fox as the cunning and tricksy deity of the desert. Islamic and Middle Eastern folklore also depicts the fox as crafty or deceitful but, like the Kitsune in Japan, also sometimes as giving aid, rather than just being out for the good of itself. In Botswana, there is a riddle that literally means 'only the muddy fox lives' i.e. work hard and you will succeed.

There are many legends amongst the different tribes of native American Indians concerning foxes.

In an early Mesopotamian myth, the goddess Ninhursag uses a fox as her messenger; even here, the fox's reputation as sneaky and devious is used to the advantage of others.

Whilst eating fox meat was considered evil in pre-Islamic Iran, it having been created as one of a group of dogs to fight a demon, it was acknowledged that fox body parts do have medicinal properties. Even fox droppings were thought medicinally useful and in Khoisan culture, for instance, a bridegroom who failed to consummate his marriage would be advised to leave the wedding and go into the desert until he hears the cry of the fox and then return and try again.

There are many legends amongst the different tribes of native Americans concerning foxes.

The Jicarilla Apache Nation of New Mexico have a legend about the first time the fox howled. Fox was trying to make his children have spotted coats like the fawns that he saw in the forest. He asked the deer how they had got their spots and the reply was that they made a fire of cedar wood and the flying embers from it burned the spots into the fawn coats. Fox, of course, gets it wrong. He puts his cubs before the fire, but, as nothing happens, he places them directly into the flames and they die. Determined to get revenge on the deer, he finds them in a copse of cottonwoods, which he sets alight. The deer, however, are able to run through it and escape. The fox cries with sadness and is still crying to this day.

An Inuit one has a lone hunter coming home to find his house tidy, his skins scraped and dried and a meal ready for him but with no signs of the person who did it. He leaves to hunt one day but decides to hide instead and, as he watches, a fox enters and, thinking it is after food he slips in himself, to find a beautiful woman working in his house, with a fox pelt hung up nearby. The woman says that she is his wife and will look after him. Time passes and the man realises there is a pungent odour in the house. The fox wife says it is her and if he doesn't like it she will have to leave. Quietly unseen one night, she slips away and never visits him again. Another Inuit tale sees the clever fox outwitting a raven to save the tribe from starving.

Depicted by them as a warrior, the ancient Moche people of Peru always had the fox using his brain rather than his physical nature. He was often depicted in their art and worshipped by them.

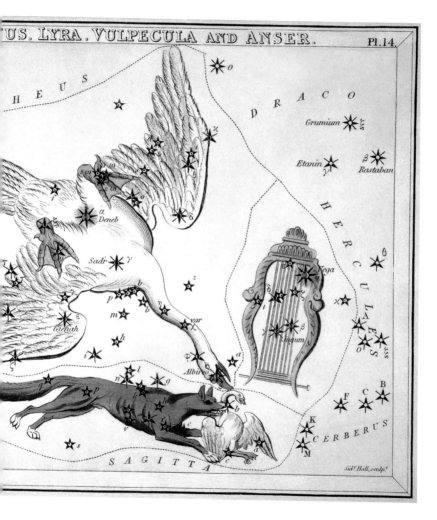

Superstitions

Worldwide there are many superstitions regarding foxes. Sometimes they are things that make perfect sense, for instance, 'when a fox's coat is thick in the autumn there will be a long winter' to the unlikely – 'many young foxes in the spring of the year mean that there will be lots of beechnuts in the autumn'.

Here are a selection of fox superstitions from around the world:

In **Iran** it is a sign of rain when a fox barks at night.

In **Korea** if a fox barks with its face pointing in your direction it means that someone you know is going to die.

In **Greece** it was believed that the urine of the fox would kill vegetation.

Bretons believe that to keep foxes from the hen house it should be sprinkled with water in which pig entrails have been boiled.

The Cherokee of **North America** called up red foxes in their frostbite cure ritual; possibly they thought the animal would help as they saw them moving freely through a snowy landscape.

In **Wales** a single fox is considered lucky but multiple foxes are just the opposite.

Also Welsh is the belief that a fox near your home means illness is on its way.

Scottish farmers believed they would frighten witches away by nailing a fox head to the barn door.

Non-area specific superstitions

Fishermen believed it unlucky to meet a fox when setting out in the morning.

White foxes were a bad omen.

Being bitten by a fox was particularly unlucky and you would die within seven years.

The story of how foxes get rid of fleas always seems a 'superstition'; they pick up bits of wool to make a largish ball, or a stick if no wool is available, and back slowly into deep water. Their coat gets wet and gradually the fleas move up the fox's body until only the nose, still holding the wool/wood, is left. At this point, the fleas migrate to the stick or wool; the fox lets go, and the flea-ridden object floats away. However, on researching this I found an account written up in the 'Baltimore Sun' of

22nd December 1900 "...the local hunter and naturalist referred to, strange to say, had never heard or read of this story when he told of the actions of the fox which he observed in the waters of the Patapsco river. The little animal, he stated, backed into the river slowly with so much deliberation that he wondered what it meant. It carried something – he did not know what – in its mouth, and dropped the something when out in deep water. Then the fox hurried away. The object left floated near to the observer, and he hauled it ashore with a stick. Fleas literally swarmed through the object, which was found to be a bit of raw rabbit fur. The observer had the puzzling mystery explained to him. He says his admiration for the shrewdness of the fox grows more and more as he grows older and learns his ways."

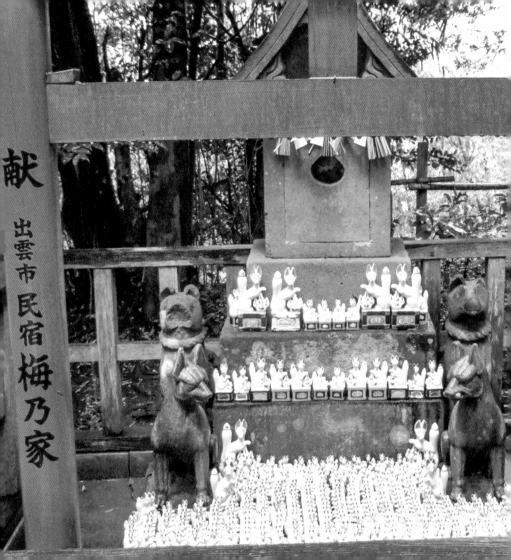

献

出雲市 民宿 梅乃家

Kitsune, Huli Jing and Kumiho

The fox features in Japanese, Chinese and Korean mythologies and, whilst they all have similarities, they are different. In Japanese, kitsune is a fox, the mammal, whilst the Chinese huli jing is a fox spirit, not an ordinary fox; it takes hard work and training to be a huli jing. The Korean kumiho is a fox that is a thousand years old, at which point it turns into a kumiho, with nine tails. Whilst both kitsune and huli jing are thought of as morally fluctuating, the Korean kumiho is definitely wicked and often portrayed as eating human flesh, particularly the heart, and liver.

Kitsune: Japan

The fox plays a very important role in Japanese mythology. The Japanese word for fox is kitsune and there are two types: myobu is the benevolent, celestial, white fox, who serves Inari – the fox spirits – and nogitsune is the wild fox, who serves no one, and is capable of evil or malice.

The fox is part of the Japanese Shinto religion.

Shrines to the god Inari are found all over Japan and they always have two white foxes guarding the door, white being the colour of good omen. These foxes are seen as guardians of the shrine and messengers to the god; they would act as a go-between to ask for help if it were needed.

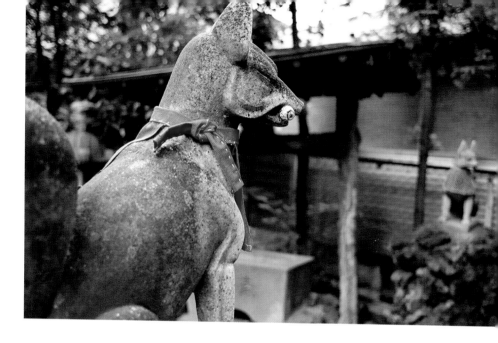

Inari means rice and, as you would expect, rice was in ancient times the staple food and symbol of cultivation, of life itself. In contemporary Japan, shrines are still to be found to the semi-divine fox in rural woods.

Kitsune are known to have specific attributes, intelligence, magical powers and long lives. This last characteristic is indicated by numerous tails. The older and more powerful the kitsune, the more tails they have. Some folk tales suggest that the fox gets an extra tail every one hundred years, and, on gaining the ninth, its fur changes to white or golden. They are considered to have knowledge of all things everywhere in

neither possessing nine tails.

An essential characteristic of the kitsune is that they are shape shifters, particularly impersonating beautiful women. Changing into a human is the preferred option, with statues a distant second choice and everything else far behind. Transformation isn't easy and requires serious thought on the part of the fox.

In ancient Japanese myth, any woman seen alone at dusk could be a fox, and, whilst the body will change, the fox face characteristics remain the same. There are no

the world. In traditional folk tales, the most usual tail numbers are one, five, seven, and nine and the name for the nine tailed fox is kyubi no kitsune.

Japan is home to two red fox subspecies, the Hokkaido fox, *Vulpes vulpes schrencki* and the Japanese red fox, *Vulpes vulpes japonica*,

stories, however, of women turning themselves into foxes. Images of the change from fox to human often show the fox wearing a large leaf, reeds or stalks, or even a human skull over its head.

Foxes traditionally have three forms: firstly, a mammal fox, with or without extra tails. Secondly, a human scale fox wearing clothes, most often seen in images but not explained in texts. Thirdly, slow transformation from human back to fox does sometimes lead to a sort of fox-human form and this might be the point at which someone 'saw she was a fox'. However, a quick transformation, if a fox is frightened, is instantaneous.

The hiding of the tail can be a problem for a transformed fox! Therefore, looking for the tail when the fox has his guard down, maybe when it is under stress, tired, or even drunk, is a recognised method of checking whether a person is in fact a fox. However, one famous story

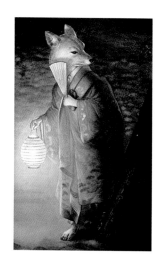

has it that the attribute most difficult to conceal was the paws. Daji, the Emperor's concubine, covered her paws with bandages to hide them and so began the vogue in the court for foot-binding. However, many images show the fox/human with fox ears, eyes or other features, although there appear to be no actual written myths that support this idea. Another key 'tell' for a fox transformed is their hatred of dogs,

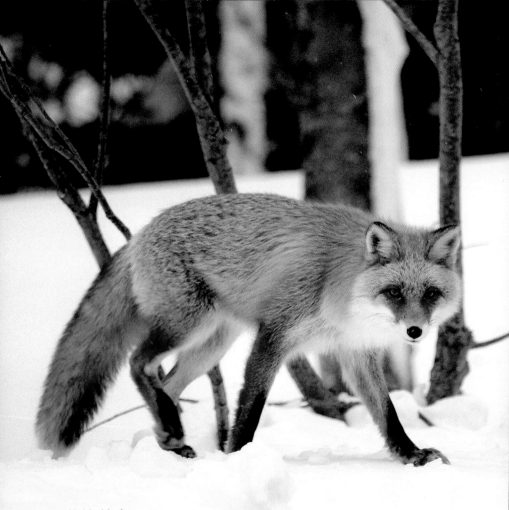

Hokkaido fox

and this can sometimes actually make them return to fox form and take flight.

There is also a recognised state of being possessed by a fox, kitsune-tsuki, a diagnosis often given to sufferers of mental illness until the early 1900s. This explanation of strange behaviour is not currently used but there is still a medical condition, kitsune-tsuki, which is based on the Japanese cultural belief that one can be possessed by a fox.

Many tales across a range of civilisations depict the fox with the same wily, trickster characteristics, but in Japan they can also be seen as true friends, lovers and guardians. As always, it depends on which particular version of a story you read and the context of the tale. For instance, The Konjaku Monogatari is a rare 31-volume book of fantastical tales, for which several suggestions of authorship exist; two Buddhist monks and Minamoto-no-Takaku

amongst others. The date is also unspecified but the volume is thought to have first emerged as a written piece during the 12th century. The work is comparable to Aesop's Fables or The Arabian Nights, in that it has tales from India, China and Japan. In this work, kitsune are depicted as wanton; they will use the art of bewitchery on man to satisfy their desire for congress with them. The fox using its superior intelligence to beguile a man is a very traditional

Japanese image of kitsune.

The 'good' trickster nature of the fox may be used against those who need taking down a peg or two: the avaricious, the greedy, the boastful. More malicious tricks might be played on ordinary mortals. Men feature as the centre for these tricks, women usually being the subject of possession.

Kitsune are regularly seen as 'witches familiars', like cats, with supernatural powers that can produce fire from their tails or even breath fire. Fox fire, known as kitsunebi, leads travellers astray, rather like the Will o' the Wisp myth in Europe.

Folklorists disagree about where the concept of the kitsune arose. Some

say it was as early as the 4th century AD, beginning only with 'good' foxes; myths of 'bad' foxes were the attributes of Chinese fox tales, imported much later. A 16th century record book, Nihon Ryakki, states that humans and foxes coexisted in ancient Japan, no doubt spurring many indigenous legends.

The etymology of the kitsune is unknown. The earliest use of the word is 794 AD and one suggestion is that it comes from the yelp of a fox: 'kitsu'. This terminology is very old, and in modern Japanese that famous shriek we all know so well, translates as 'kon kon' or 'gon gon'.

There is a well-known folk etymology dated from a legend of 545 AD, that places the word as coming from the tale of Ono, a husband who lived in Mino, and his 'fox-wife'. She was afraid of Ono's dog, so much so that she would leave their house in the morning and spend the day as a fox and return to spend the night in

his arms as a woman. She became known as Kitsune. The belief is that the term 'kitsune' comes from kitsu-ne, meaning 'come and sleep', and 'ki-tsune' meaning 'always comes'.

Kitsune are often depicted with a ball called hoshi no tama. These can be round or sometimes shaped like an onion.

These balls are usually assumed to be jewels or even pearls. The ball will be kept in its mouth by the fox or even on its tail. Jewels are

The Foxes' Wedding

associated with Inari, and her foxes are rarely seen without them. The ball is thought to hold a kitsune's magic powers and if they are acquired by a human, they may gain favour with the fox, a favour that will be repaid. Kitsune are very specific; promises are kept and favours returned. Respect is another thread through the kitsune tales. They will use their magic to help a human or even a household, but the humans must respect kitsune in return.

Kitsune are often depicted in tales as lovers. A man will have a liaison with a fox-woman and, on discovering this fact, the fox-woman will be forced to leave. Sometimes this scenario ends with the man awakening as from a dream, dirty, confused and possibly a long way from his home!

The story of Kitsune No Yomeiri, 'the foxes' wedding', is a sweet one. When rain falls from a clear blue sky, this is called a sun-shower, or the kitsune's wedding, as marriages

between kitsune are said to take place when these unusual conditions are present. It is considered a good omen, but beware, revenge will be wrought on any uninvited guest who witnesses it.

The kitsune are alive and well in Japanese culture today, as further research into anime and manga will prove.

Huli Jing: China

The Chinese term huli jing literally translates as 'exquisite fox'. Another term for the fox in China is 'Huxian', translating as 'immortal fox'. In China, the fox is a private spirit to be prayed to at home, along with other animal spirits, and sacrifices to it would be offered at a home shrine.

Huli jing are the half-way point between the kindly and benevolent Japanese kitsune, and the almost always ferocious Korean kumiho. The huli jing can possess a human from afar and shape-shift at will, but this will almost always be used to gain knowledge by turning into a human.

Described in the *Classic of Mountains and Seas* (an ancient text, of the 4th century BC) as having nine tails, the fox spirit later reverted to the more usual single tailed ordinary fox, although it still took training and hard work to become a huli jing. These days, the term huli jing is more likely to be used as a negative term to describe the mistress in an extramarital affair.

Kumiho: Korean

The Korean version of the kitsune and the huli jing is the kumiho, or nine tailed fox. The kumiho is always an evil character, sustained by eating the heart and liver of humans which it kills when transformed. The sole raison d'etre of the kumiho is power and death. The only mythological fox that kills and eats its prey itself, everything about it is up close and personal. There are many legends of how the malevolent kumiho wreaks havoc in the village, the forest and even the palace of a king. One legend tells of how a bride is replaced by a kumiho, taking the bride's likeness. The difference is not even recognised by the bride's mother and is not revealed until the bride is naked.

Naturally, like spirit legends in the west (vampires and werewolves etc.) there are variations on this bald narrative. A popular version is that the 'monster' nature of the kumiho could be left behind and it could become a human. How this is achieved varies depending on who is doing the explanation, but it usually involves either not killing or eating flesh for anything up to a thousand days, or the exact opposite. Not surprisingly, the kumiho is a favourite with the horror film/book/graphic book market. The fact that kumiho are most often portrayed as women is a gift for these representations and the 'manga style' drawings that they inspire.

St Brigid and the Fox

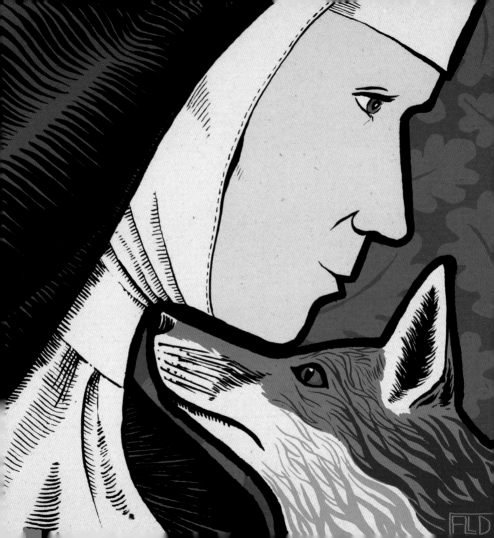

The saint was known for her ability with animals as well as people; she was something of a clever fox herself. One day she heard the tale of a monastery workman who had accidentally killed a tame fox belonging to the King of Leinster. The fox had many tricks and was very beloved of the King who, in retribution for its death, had sentenced the poor man to be executed. The King ignored the pleas of family and friends and decreed that the punishment would be administered quickly. St Brigid felt aggrieved that the man should lose his life in exchange for the fox and so she called up her horse and cart and set off for the King's court to plead for him herself.

On the way, passing through a copse, she found herself praying for a way to save the man's life. Just then, she saw a fox watching her through the trees. Calling to her driver to stop, she coaxed the fox into the cart. It seemed to come willingly, and

snuggled in beside her in the folds of her cloak. Thus, calmly and side by side, they finally reached the court of the King.

With the fox walking quietly behind her, they entered the castle, where Brigid found the King still furious about the fate of his fox friend. He shouted that the idiot who had killed it must die as a warning to others. St Brigid agreed that it was a pity the animal had died but that it had been an accident. She said she loved animals as much as anyone, in fact, (and here she ushered forward her newly found helper) would he like to see how wonderfully able her pet was?

As the little fox ran through a gamut of clever tricks, all completely new to it but directed by St Brigid, the feeling of the court changed from anger to pure delight. She held up the corner of her cape to form a circle and the fox jumped through it, just as the King's fox had

jumped through a hoop. It begged for a titbit with paws together as though praying, just as the King's had done. Finally, Brigid suggested that the King might like the little fox in exchange for a stay of execution for the monastery workman. Not surprisingly the King agreed.

All was well, the man returned to his family and Brigid returned to the monastery. The only person not happy was the little fox, who missed Brigid and its freedom, and became dreadfully unhappy. Being the clever little fox it was, however, it bided its time until the King was away from court and slipped out, back to the woods. For the fox, the woods without Brigid were bearable. The castle without her was just a prison.

When the King returned, in spite of his pack of hounds and eventually his whole army searching, the little fox was never found, and, with nobody to blame, all but the King lived on as they had before.

The Black Fox by Jackie Morris

This story is dedicated to all those who are hunted.

There are those who measure out their days by the hands of a clock, their weeks and months by the turning pages of a calendar.

There are others who measure time by sun's rising and falling and the turning of the world, by the coming and fading of snowdrops and bluebells, the arrivals and departures of swallow, leaf bud and blossom and the colour of autumn trees.

She was one of these.

She did not believe that time should be shackled to the hands on the face of a clock.

She thought it the devil's work.

She lived in a small cottage, deep in the heart of a patch of wild woodland.

Little was known of this solitary soul.

People loved to fill the space around her life with speculation.

She owned both house and land.

These two facts, and her dark, wild beauty, were what drew her to the attention of the Lord of the Manor.

He owned everything around the wood.

He could see it from the room in the tower where he slept at night.

He wanted everything, wood, cottage and woman.

He wanted the house because it irked him that this one patch of land was not his.

He wanted the wood because he loved to hunt and whenever the hounds caught the scent of the fox it would bolt to her woodland for sanctuary.

He wanted the woman because he loved her, or thought he did.

And he did so love to hunt.

It was said that her father was a highway man, who waylaid travellers on the woodland road and stole money and jewels.
That, it was said, was how he bought the house for his child.
The truth, known only to a handfull of people, was that her father was a freed slave who wandered the land in search of answers.
Her mother was the highway woman who dressed as a man.
Her disguise worked well.
She died a peaceful death of old age.
While she plied her night-time trade her young daughter was left to the care of the wildwood foxes and hares.

At first the lord tried to win her love with trinkets.
She turned him away.
She did not want him, nor his gifts, for his eyes were cruel, even when he spoke with soft words.
Had he brought her foundling birds or wildling cubs she might have looked more kindly on his suit.
But he knew the cost of everything and the value of nothing, so he brought her diamonds and garnets and rubies.
He measured his worth by the acres he owned, the ships and plantations, by the money and jewels in his bank vaults.
As she spurned his gifts and his touch, he grew to hate what he could not have.
And yet he burned around her like a moth to a flame.
Having failed to buy her love, he tried to buy her house and her woodland, but this also came to nothing.

When her house burned to the ground some people thought it
an accident.
Some around felt that she had got what she deserved, for there are
always those who fear a woman who chooses to live alone.
Witch, they called her.
Others whispered that he was to blame, that he had gone to her
house, taken what she refused to give and burned both woman and
house to the ground to hide the evidence.
But he was the Lord of the Manor.
No man would say this to his face.

It was only a few weeks after the fire that the black fox appeared.
Almost as large as a wolf she was, with stars in her eyes and a tail
like the dying of the crescent moon, they said.
She soon became a creature of omen.
One by one she picked off all the hens in the manor's farm.
He would see the fox at twilight in his garden, set the hounds to run
her down, but always she eluded them.
He began to suffer ill fortune.
One by one his ships all sank, investments failed.
His servants began to slip away as his mood grew darker.
They feared he was cursed.
And the black fox would call, all night in his garden, a mating shriek
like the ghosts of the dead calling from hell, troubling his dreams
even when he managed to sleep.
Things fell apart and he slipped towards madness.

The look in her eye reminded him of someone,
but he would not say who it was.
So he vowed to kill her.

He bought, with the tattered remnants of his fortune,
the swiftest hunter that money could buy,
he unleashed what was left of his pack of hounds and
at dawn they rode out.
They say the black fox came to meet him, goading his hounds with
her fearful cry.
They say she ran the hounds ragged until their paws were bloody
and their bodies broken. By dusk light they could still be heard
baying to the rising moon.
All night he rode, as fast as the horse would carry him,
but no matter how fast they galloped
the black fox always ran faster.

By first light the next day he was gone, his horse was gone,
his hounds were gone.
Some say he rode so fast he crossed over the river that runs
between this world and the next.
Others say the devil took him for his own.

The black fox still wanders through the gardens of the manor
house, but now the wild wood trees have taken it for their own,
seeding the lawns with sapling oaks, climbing ivy over
the statues and fountains.

The manor house windows are blind now, the stone walls
tumbled in ruin.
Men fear sighting the black fox dark as midnight with stars in her eyes
and a tail like the the crescent moon.
They think her a creature of ill omen.
The devil's own.

Women know better.
No one could say exactly when it began, but women began to wear a
black fox, hidden, stitched into their clothing, on a chain around their
neck, a brooch pinned beneath a scarf, inside a hat.
They drew the shape of her in dark charcoal, in hidden places in their
homes, above a girl child's crib, to protect the home, to protect the
heart, to protect the life, against the cruelty of some men.

The fox in art
and literature

Medieval Marginals and Misericords

The texts of medieval manuscripts are of great importance to those who study these things. To the fox lover however, the interesting things about these ancient writings are the 'marginals', the tiny elaborate drawings found at the bottom or sides of the pages.

These marginals were used to tell moral tales. On page 106, a fox is shown feigning death to catch birds; he waits until they come to peck over the body and then grabs one! (The moral being the fox is the devil, pretending to be dead to those of a 'worldly' nature, whilst he is completely dead to those of the true religious ways.)

This particular tale of bird deception has been told for centuries in both marginals and misericords (the carved shelf which supports a drop-down seat in a church, often used to give respite to those standing for long prayers). In the carving on the page opposite the fox is in the pulpit preaching to the geese and below, the illustration of a 'monk' fox from the Netherlands shows that the idea was also known on the continent.

In the bottom left of page 110, a fox runs off with a goose over its back, chased by the lady of the house. (See 'A Fox Went Out On A Moonlit Night' later in this chapter.)

jot·s·tccte i notuit uec metate·s·ccruis quue ce̅
mpcta·l·u·et·ay·si cum bus qm̅ pac̅mtur o̅ sc̅ui i
ordie satis mtc̅tur fieri q̅·ɑo buc potest ar̅ept oi̅sp

The misericord above tells the same burgling tale. This fox is stealing the goose but being chased by the other geese. (See the next section on Chanticleer and the Fox.)

A fox getting the better of birds is a regular theme in marginals and Reynard the Fox was easily recognisable to the non-reading public in medieval times.

However, in this misericord below from Bristol Cathedral, the geese have their own back and are hanging the fox!

The Funeral of Reynard the Fox is depicted in great detail in the marginals of *The Book of Hours* from the 13th century. We see the rabbit tolling the bell and goat and cockerel officiating with staff and censer. The music is supplied by a bear with a 'pipe', a cat with a hand drum and a dog playing the bagpipes (page 112).

Details from The Funeral
of Reynard the Fox
in the marginals of
The Book of Hours,
13th century.

Chanticleer and the Fox

By the time Geoffrey Chaucer used the basic story in 'The Nun's Priest's Tale' in *The Canterbury Tales* in 1390, the story of Chanticleer and the Fox had been around for a long time. Although not originally one of Aesop's Fables, it spread throughout Europe during the medieval period and was included in the Fables in the translations by Heinrich Steinhöwel (1476) and William Caxton (1484).

A coloured illustration of the fable from Steinhöwel's *Esopus*, c.1501.

In the 11th century Ademar de Chabannes wrote in Latin about a fox and a partridge and by the 12th century the tale had become part of the Reynard cycle – appearing in an adaptation by Marie de France, written in Old French verse. There are differences, of course, amongst the many versions but the core tale remains one of low cunning on both sides. A fox, by charm and flattery, cons a cockerel into keeping its eyes shut and stretching up its neck, whereupon the fox grabs it by the throat and runs off with it, pursued by farm workers and animals. At this point the cockerel cons the fox into shouting at them to give up the chase. Naturally, as soon as the fox opens its mouth, the cockerel escapes to the trees.

A medieval illumination of the *Renart et Chantecler*, artist unknown.

Each animal blames the other for the credulity and pride that has brought them to the situation.

The variations cover a hurt paw for the fox, a crow or partridge instead of a chicken and the chase with dogs, without dogs or even mixed animals. The cockerel has one wife, three wives, or, in Chaucer's version, seven wives. Sometimes there is a dream sequence where Chanticleer foretells his downfall. However, it is obvious that the nature of the tale remains the same: pride comes before a fall in all its forms.

There were three British versions whose length and popularity gave them subsequent stature. There was Geoffrey Chaucer's version, told in 'The Nun's Priest's Tale' in *The Canterbury Tales*, John Dryden's translation in 1700, titled 'The Cock and the Fox' and, Robert Henryson's version written in the 1480s. Henryson's version borrows heavily from Chaucer's tale, although the Scottish poet also added material of his own.

There have been musical settings of the story and numerous settings for children, as well as plays and a never-released Disney animation, all proving the endurance of a good moral fable where the point is proven but nobody really gets hurt.

Reynard The Fox

It is amazing that the cycle of stories featuring Reynard The Fox, first thought to have come from Alsace-Lorraine, spread via oral tradition through France, the Low Countries (generally considered to be the Netherlands and Belgium) and then Germany. Although Reynard makes an appearance in medieval Latin poem 'Ysengrimus', c. 1148-1153, the first written version with his name in the title seems to be *Le Roman de Renart* by Pierre de Saint-Cloud, c. 1170, written in Old French. Reynard the Fox later appears in a Middle High German poem *Reinhart Fuchs* by Heinrich der Glïchezäre, c. 1180.

The tale would have been easily understood by all who heard it. It was a satire on life for the peasant class, with the targets being the ruling aristocracy and the church. The story is peopled with anthropomorphic animal characters, including Reynard's most ardent foil, the dull-witted wolf Isengrim. The cunning and sly attributes Reynard displays would have been seen as necessary for survival in that harshest of worlds, and the tales became so popular and well loved that the word *renard* came to replace the traditional word *groupil* for fox in French. The Middle Dutch version of the stories by Willem die Madoc (*Van den vos Reynaerde – Of Reynaert the Fox*) c. 1250, was the template for the spread across Europe and was used by Dutch, German and English adaptors. Chaucer used and adapted the characteristics of Reynard in 'The Nun's Priest's Tale', paying tribute in naming him Rossel. In 1481 William Caxton produced *The Historie of Reynart the Foxe*, using the Madoc text as his source. Robert Henryson

developed the tale of Reynard in his 'The Talking of the Tod', from *The Moral Fabillis of Esope the Phrygian*, c. 1480.

The progression of Reynard continued. Ben Jonson's play *Volpone* (Italian for 'sly fox'), written 1605-06, contains characters and themes that the original medieval audience would have recognised, greed and lust being timeless. A popular satire and perhaps one of the best of the Jacobean era, it was produced as recently as 2015 by the Royal Shakespeare Company at Stratford-upon-Avon, with Henry Goodman as the scheming Volpone.

Wolfgang Goethe wrote his version of the story, *Reineke Fuchs*, in 1793. It was later illustrated for children by the well-known illustrator Fedor Linzer in 1881.

There was even an anti-semitic Dutch version, *Van den vos*

Reinecke Fuchs Leutemann 1880.

Reynaerde, serialized in a monthly publication by the Dutch Nazi Party. It was later published as a book in 1941.

Reineke Fuchs

VERLAG von CARL FLEMMING in GLOGAU.

The cunning and sly attributes Reynard displays, would have been seen as needed for survival in that harshest of worlds and the tales became popular and well loved.

Oddly, the tale centres around Reynard as the hero, out manoeuvring the central character Jodocus (possibly inspired by the Dutch word for rhinoceros, jood). Jodocus is portrayed as the outsider, who comes to the Empire and makes changes within it but Reynard and the other animals eventually kill him. A cartoon was made in the Netherlands in 1943 but it was never released. The Dutch Jews by that time had already been moved to the concentration camps and the depiction of a fox, traditionally seen as a villainous character, as a hero never sat comfortably with the Dutch. There was no benefit to the Nazi cause to be made and so the project was shelved. A restored version of the animation was shown in Holland in 2008.

Other adaptations include a 1962 film, *Black Fox*, equating the rise of Hitler with the Reynard tale. Walt Disney contemplated animating the story but felt that the character of Reynard was an unsuitable hero. They tried incorporating it with the tale of Chanticleer the cockerel but that fared no better. Eventually, Disney released *Robin Hood*, with a Reynard-like Robin Hood and a Sheriff of Nottingham who bears a striking resemblance to Isengrim the wolf.

It is an enduring story that continues to resonate to this day.

Left: Reineke Fuchs Flinzer 1881.

Fox at Dawn

It was June and I was up with the light,
Hidden by a hedge,
Waiting for owl, who,
took barn as launchpad,
farmtrack as silent motorway
for the four a.m. hunt.

A hare stood up,
as a whiteness came from the blue,
a shock of feather and wing,
before it lolloped in a
curved calligraphy off into the half day.

And there, to my left, over that same hedge,
A sprinting fox, eating the yards with ease.
Dog fox, owner of these acres,
comfortable with grass and dawn.
I caught him with a click,
let him go,

On my way home,
the stink of diesel like a scent,
clogged my nostrils
and the keeper drove up,

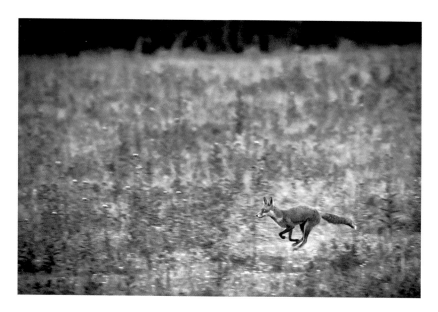

In a Landy as battered as his face.
On the bonnet, fox,
no longer sprinting,
but spread in death, elegant and bloody.

The double take.
For fox is no friend of curlew,
is proved the reason for no breeding where I live.
Voracious, the eat-all.
And keeper?

Well, his job,
predating the predator.

This is no song of justification,
but is what it is.
And for the record,
nor would I be like the Victorians,
who took every pine marten and reduced that species to a myth.
And the slaughter of hares
and poisoning of hawks are the blackest of stains,
on estates where profit maketh not the man.

For I love fox and badger
and the long haired fallow deer,
who live only in a single Shropshire wood.
And I would ask for balance, and respect
and reality for all the business of our diminishing wilderness.

Andrew Fusek Peters

Echoes

The call that breaks the night in country or in town
may easily be deduced.
Nothing on earth compares to the first time shock
of hearing a vixen scream.

Her call, a chilling combo of yell, screech and howl
may summon a passing male
but its other-worldly sound has deeper meaning.

Each yelp and shriek echoes the screams of pain
and outrage of countless foxes down the centuries,
hunted to their savage death by horse and hound,
their blood spattered and their corpses torn
across the shires of England,
a vehicle for human bloodlust.

So when that call arrests us we should think
not only of a vixen hot to mate
but the burning outrage to her kith and kin.

Charles Middleburgh

Mr Foxy

The household sleeps,
and through the thick black night,
a russet shape oozes a gap in the hedge.
The countryside has come to town.

In fact the countryside was always here.
We never saw the gentle takeover
of our gardens and unwanted places.
That is, until we heard the now familiar shriek at the turn of the year.

Their visits form the highlight of lonely days.
Fed by the many in Metro land,
a super highway of vulpine 'restaurants'
stretch through the suburbs.
Love or hate him,
the fox is always with us.

Jane Toole

Extract from *The Little Blind Fox* by Karen Green

"Hello?..." said the little fox in his littlest voice, in the thicket where he hid.

"Is there anyone out there?"

He had heard many noises over the days and nights, but this was the first time he had called out.

"Hello", said a much bigger voice back. It was not his mother's voice. The little fox did not care. He was not alone anymore, and slowly, bravely, feeling his way, he emerged from the thicket. As he picked through the prickly thorns he could feel the warmth of the sun on his face and he knew it was not night anymore.

"Have you anything to eat?" he asked, for his tummy was terribly hungry, he had been hiding for such a long time.

"No" said the voice, in a kindly sort of way. He felt he might cry, but his mother had taught him to be brave, so he knew he mustn't.

"Have you seen my mother?" he asked the voice but again the voice said "no".

And then there was no sound, a pause so hollow and long, just silence. And the little fox knew he could not go back to his hiding place.

"May I walk with you a while?" And the voice said "yes, little fox. You may walk with me. But I am very slow and have been walking a great while. Perhaps you could give an old girl a ride?"

The little fox had not carried anyone on his back before, but he knew he was strong. His mother had told him so many times, and so he crouched down and waited. The little fox felt two wide feet step upon his back and a huge weight settle between his shoulder blades. He wondered what kind of beast was upon him.

At first he believed he could not stand, and his passenger slipped and tottered as if to fall off. The little fox took a deep breath and pushed his tired and hungry self up, with all his might. And with this first full inhale, a glorious smell travelled into his nose, lifting his mind and body and soul, as if as one. And in standing his stomach sang out "You smell delicious"

"I should" retorted the voice with glee "I am very good looking"

"Forward" shouted the voice above him now, and the little fox began to walk slowly, delicately placing his paws upon the sandy road. As he walked, the voice corrected him with a few soft directions and rather more cries of hazards and disaster. The sound of his paws upon the ground, relaxed the little fox, and soon he felt quite happy, counting 1,2,3,4...1,2,3,4...1,2,3,4. This was much better than hiding, even with the extra weight and all the yelling.

And as he walked, between the shouts, he began to think.

"It is no wonder you are so slow", he mused. "Why do you have only two feet, when I have four?"

"I do not need an extra set of feet when I have these magnificent wings", replied the voice.

Suddenly, with an unexpected whoosh of air, his passenger seemed to both expand and lift upon him. A great force pounded the air all around them, as if to push back the world, beating the dust from

the road into his mouth and nose. This commotion of dirt clogged the air, soon with fits of coughs and splutters, the two were left just a heap on the ground.

A titter of laughter came from above.

"What are YOU laughing at, you silly birds!?" demanded his upended rider.

"YOU, you silly goose!" said one.

"Lying in the dirt boasting of your magnificent wings!" laughed another.

"What use are they when they've been clipped" mocked a third.

"You couldn't fly over a garden hedge!" interjected a fourth. Then they all laughed again.

"And even if you had decent wings, you are too fat to fly", and with that, there was a flutter from above, and the little fox heard the laughter disappear above him and away.

Desperately he cried after them "have you seen my mother?" but his voice trailed off when he realized they were gone, only their distant laughter remained as a reply.

"Well they weren't very nice," said the fox finally, but the goose said nothing.

"Never mind them. Climb on goose. Your wings sounded magnificent to me, whether you can fly or not"

And so the two continued, goose now more subdued than before, until suddenly she rose high and bossy once again. "STOP!" she demanded, "We have come to the woods. We will ask everyone we meet about your mother."

(P.S. For those who are anxious, there is a happy ending!)

Extract from *Reynard the Fox* by John Masefield

In 1920, the acclaimed poet, lecturer and future poet laureate John Masefield, wrote a poem called 'Reynard the Fox'. It was a detailed and amusing description of the gathering and subsequent 'run' undertaken by a country hunt.

The poem shows the nature of the English countryside, which Masefield obviously loved, along with the people who lived there. It is reminiscent of Dickens' lucid and delightful descriptions of his characters.

The fox he paints with just as many well chosen words as the humans. It is hard to read of his plight however; he starts not that worried by the chase, until slowly he realises that all his escape routes are blocked or unavailable. Here are some verses from the end of the poem to give a sense of the whole – it being far too long to print in full.

He made his spurt for the Mourne End rocks.
The air blew rank with the taint of fox;
The yews gave way to a greener space
Of great stones strewn in a grassy place.
And there was his earth at the great grey shoulder,
Sunk in the ground, of a granite boulder.
A dry, deep burrow with a rocky roof,
Proof against crowbars, terrier-proof,
Life to the dying, rest for bones.

The earth was stopped; it was filled with stones.

Then, for a moment, his courage failed,
His eyes looked up as his body quailed,
Then the coming of death, which all things dread,
Made him run for the wood ahead.

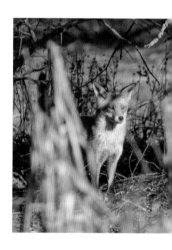

The taint of fox was rank on the air,
He knew, as he ran, there were foxes there.
His strength was broken, his heart was bursting,
His bones were rotten, his throat was thirsting;
His feet were reeling, his brush was thick
From dragging the mud, and his brain was sick.

He thought as he ran of his old delight
In the wood in the moon in an April night,
His happy hunting, his winter loving,
The smells of things in the midnight roving,

The look of his dainty-nosing, red,
Clean-felled dam with her footpad's tread;
Of his sire, so swift, so game, so cunning,
With craft in his brain and power of running;
Their fights of old when his teeth drew blood,
Now he was sick, with his coat all mud.

He crossed the covert, he crawled the bank,
To a meuse in the thorns, and there he sank,
With his ears flexed back and his teeth shown white,
In a rat's resolve for a dying bite.

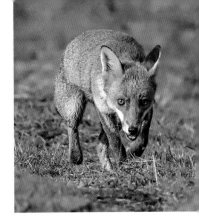

And there, as he lay, he saw the vale,
That a struggling sunlight silvered pale:
The Deerlip Brook like a strip of steel,
The Nun's Wood Yews where the rabbits squeal,
The great grass square of the Roman Fort,
And the smoke in the elms at Crendon Court.

And above the smoke in the elm-tree tops
Was the beech-clump's blur, Blown Hilcote Copse
Where he and his mates had long made merry
In the bloody joys of the rabbit-herry.

And there as he lay and looked, the cry
Of the hounds at head came rousing by ;
He bent his bones in the blackthorn dim.

But the cry of the hounds was not for him.
Over the fence with a crash they went,
Belly to grass, with a burning scent;
Then came Dansey, yelling to Bob:
"They've changed! Oh, damn it! now here's a job."
And Bob yelled back: "Well, we cannot turn 'em,
It's jumper and Antic, Tom, we'll learn 'em!
We must just go on, and I hope we kill."
They followed hounds down the Mourne End Hill.

The fox lay still in the rabbit-meuse,
On the dry brown dust of the plumes of yews.
In the bottom below a brook went by,
Blue, in a patch, like a streak of sky.
There one by one, with a clink of stone,
Came a red or dark coat on a horse half-blown.
And man to man with a gasp for breath
Said: "Lord, what a run! I'm fagged to death."

After an hour no riders came,
The day drew by like an ending game;
A robin sang from a pufft red breast,
The fox lay quiet and took his rest.
A wren on a tree-stump carolled clear,

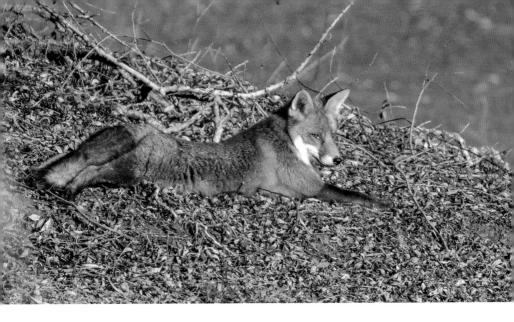

Then the starlings wheeled in a sudden sheer,
The rooks came home to the twiggy hive
In the elm-tree tops which the winds do drive.
Then the noise of the rooks fell slowly still,
And the lights came out in the Clench Brook Mill;
Then a pheasant cocked, then an owl began,
With the cry that curdles the blood of man.

The Fox Went Out On a Chilly Night

The earliest version of this song appears to have been a Middle English poem,
dating from the 15th century, found in the British Museum.

The fox went out on a chilly night,
He prayed for the moon to give him light,
For he'd many a mile to go that night,
Before he reached the town-o, town-o, town-o,
He'd many a mile to go that night,
Before he reached the town-o.

He ran til he came to a great big pen,
Where the ducks and the geese were put therein,
"A couple of you will grease my chin,
Before I leave this town-o, town-o, town-o,
A couple of you will grease my chin,
Before I leave this town-o."

He grabbed the gray goose by the neck,
Throwed a duck across his back,
He didn't mind their quack, quack, quack,
And their legs a-dangling down-o, down-o, down-o,
He didn't mind their quack, quack, quack,
And their legs a-dangling down-o.

Then old Mother Flipper-Flopper jumped out of bed,
Out of the window she cocked her head,
Crying, "John, John! The gray goose is gone,
And the fox is on the town-o, town-o, town-o!"
Crying, "John, John! The gray goose is gone,
And the fox is on the town-o!"

Then John, he went to the top of the hill,
Blowed his horn both loud and shrill,
The fox he said, "I better flee with my kill,
Or they'll soon be on my trail-o, trail-o, trail-o!"
The fox he said, "I better flee with my kill,
Or they'll soon be on my trail-o!"

He ran till he came to his cozy den,
There were the little ones, eight, nine, ten,
They said, "Daddy, better go back again,
'Cause it must be a mighty fine town-o, town-o, town-o!"
They said, "Daddy, better go back again,
'Cause it must be a mighty fine town-o!"

Then the fox and his wife without any strife,
Cut up the goose with a fork and knife,
They never had such a supper in their life,
And the little ones chewed on the bones-o, bones-o, bones-o,
They never had such a supper in their life,
And the little ones chewed on the bones-o.

K Wyatt

The Tale of Mr Tod by Beatrix Potter

By the time she wrote *The Tale of Mr Tod* in 1912, Beatrix Potter was a well known author who produced beautifully illustrated whimsical tales for children from her farmhouse, Hill Top Farm, in what is now Cumbria.

However, she had grown tired of the 'sweet' characters of past glories and in *The Tale of Mr Tod* she created, by her own admission, two throughly bad types in Mr Tod the fox and Tommy Brock the badger. This book, followed by *The Tale of Pigling Bland* in 1913, were her last two original works; anything produced later were reworkings of older ideas and sketches.

The Tale of Mr Tod is longer than her previous books, with 42 pen and ink sketches, and 16 full watercolour illustrations. The story begins with a badger, Tommy Brock, stealing the young children of Benjamin Bunny and Flopsy Rabbit as meal ingredients and hiding them in the unlit oven of Mr Tod's house; he then falls asleep in Mr Tod's bed. On finding him in his bed, Mr Tod determines to get Tommy out of his house. He tries several tricks, to no avail. Eventually, there is a showdown in the kitchen, accompanied by 'dreadful bad language', and it

all comes to some serious blows, starting indoors and finally ending with them rolling down the hill outside. Whilst the central characters are fighting, the baby rabbits are saved by Benjamin and Flopsy.

The whole tale is set in fields owned by Potter, not far from Hill Top Farm. Although more than happy with

her illustrations of the landscape backgrounds, which were done in Cumbria, she was anxious about how physically accurate the fox was and spent time in the Natural History Museum checking against photographs and reference books. For us today, the interiors in the book are a lovely snapshot of the inside of

'I am quite tired of making goody goody books about nice people. I will make a book about two disagreeable people, called Tommy Brock and Mr Tod.' BEATRIX POTTER

cottages in the local area at the turn of the 20th century. For instance, Tommy Brock hides the baby bunnies in a beehive-shaped oven, which was drawn from one in the Sun Inn in Hawkshead.

The influence of the Uncle Remus stories about Brer Rabbit and Brer Fox is evident; in those, it is acceptable to see the characters 'warts and all'. Nonetheless, her publisher, Harold Warne, thought the public would not like Potter's original opening paragraph: 'I am quite tired of making goody goody books about nice people. I will make a book about two disagreeable people, called Tommy Brock and Mr Tod.' He had the text edited so it read,

'I have made many books about well-behaved people.' Warne was keen to publish the tale in a bigger, deluxe format but Potter did not favour it as she felt her readers liked the small familiar originals. Although initially it was launched in the new format, for reprints Warne reverted to the standard size.

Unusually, for stories about foxes, Mr Tod does not win. He's not a naturally wily, devious character. In fact, it is Brock who is the clever one. In the end, the rabbits win overall, rescuing the babies whilst the main characters are distracted. As in the Uncle Remus tales, the weak and powerless are seen to triumph over those with power.

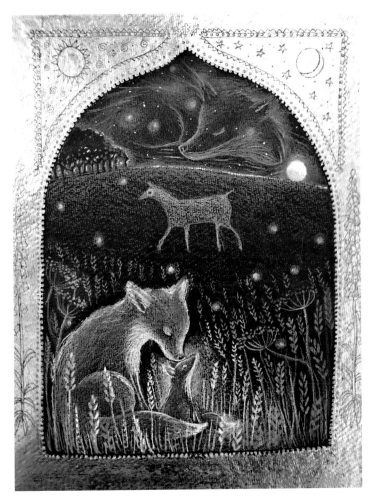

The Cunning Little Vixen

The opera by Czech composer Leoš Janáček, called originally *Příhody Lišky Bystroušky*, literally translated as *Adventures of Vixen Sharp-Ears*, is the work we know and love today as *The Cunning Little Vixen* and composed between 1921 and 1923. The story was adapted by Janáček from a strip cartoon by Rudolf Těsnohlídek, with drawings by Stanislav Lolek, published in the liberal daily newspaper *Lidové Noviny*. The story was about an intelligent vixen, known as Lišky Bystroušky or Sharp-Ears. In Czech the term Sharp-Ears has a double meaning, pointed ears and clever or sly, which was sadly lost in translation.

Unusually, the drawings came first: there were about 200 that had been done by the painter Lolek. One of the paper's editors saw them and

the law reporter for Lidové Noviny Těsnohlídek was tasked to come up with some text to run alongside.

The name of the piece was a muddle all round. When they were going to press, the setter mistook the original title used by Těsnohlídek, *Liška Bystronožka*, meaning Vixen Fleetfoot, for *Liška Bystroužka*, meaning Vixen Sharp-Ears. That became the title of the strip and therefore the one that Janáček used. However, when the opera made it

Musically, the opera uses folk tunes and rhythms that would have been recognised by the local audience and also make it accessible to 'foreign' listeners.

to a translation into German, the translator, Max Brod, used the title *Das Schlaue Fücheslein* or *The Cunning Little Vixen* and it stuck worldwide, everywhere that is, except Janáček's homeland.

Musically, the opera uses folk tunes and rhythms that would have been recognised by the local audience and also accessible to 'foreign' listeners. Most often described as a comic opera, it has also been described as everything from entertainment for children to a tragedy. Janáček, however, always saw it as a satire. The highly adaptable fox isn't interested in the conventions, she can be as anarchic as she likes.

The vigorous, exhilarating music sweeps you along in a fearless rush to the end of the tale. It was one of the composer's favourites because he could set up 'the world' of animals and then make fun of it.

Zlatohřbítek (*Gold-Spur, the Fox*) from a production of
The Cunning Little Vixen at the Chautauqua Opera New York.

Janáček does not shy away from the violence of life in the wild but it is joyful and full of fun too.

The chickens and dog are seen as stupid for having succumbed to domestication. The violence of life in the wild is not toned down here, but it is joyful and full of fun too.

In 1983, a new edition of Rudolf Těsnohlídek's cartoon strip was released with illustrations by acclaimed artist Maurice Sendak.

This version won Sendak several prestigious illustration awards and has been responsible for the look of many opera productions since.

There is a monument to Bystrouška, the vixen, in Hukvaldy, Janáček's hometown.

151

Reynardine

The origins of the traditional ballad Reynardine are complicated to say the least. It is a tune that most fans of folk music will know well, from a version by Fairport Convention on their 1969 album *Leige & Lief*.

It seems to have started life as a Victorian broadsheet entitled *Mountains High*, the main protagonist of which was some sort of bandit. It only has one reference to Rynardine, and that isn't until the last line. There appears to be no evidence for the change to the slightly supernatural, werefox nature of the currently used lyrics, beyond that at the turn of the 20th century, when two folklorists used the Reynadine name as a hook for a short poem. This was taken up by the folklorist and singer A.L. Lloyd, who recorded with the original 'Mountains High' lyrics in 1956 but called the tune 'Reynardine'. Ten years later he had written four further verses and we first encounter "sly bold Reynardine". It is mainly found in this format to the present time and even when the lyrics are those of 'Mountains High', the title used is most often 'Reynardine'.

Below are the lyrics to the version sung by Martin Carthy.

Reynardine

One evening as I rambled among the springing thyme,

I overheard a young woman converse with Reynardine.

Her hair was black and her eyes were blue, her lips were red as wine.

And he smiled as he looked upon them, did this sly bold Reynardine.

She says, "Young man, be civil, me company forsake.

Oh for to my good opinion I fear you are a rake."

"Oh no, I am no rake," he cries, brought up in Venus' train,

But I'm searching for concealment all from the judge's men."

Her cherry cheeks and her ruby lips they lost their former dye,

As she fell into his arms all on the mountain high.

They had not kissed but once or twice when she came to again

And most modestly she asked him, "Oh pray tell to me your name".

"Oh, if by chance you look for me, by chance you'll not me find.

For I'll be in my green castle, enquire for Reynardine."

Oh, day and night she followed him, his cheeks all bright did shine,

As he led her over the mountain, did this sly bold Reynardine.

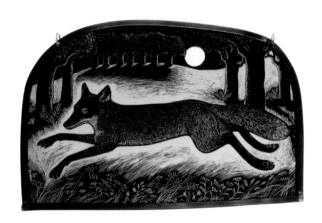

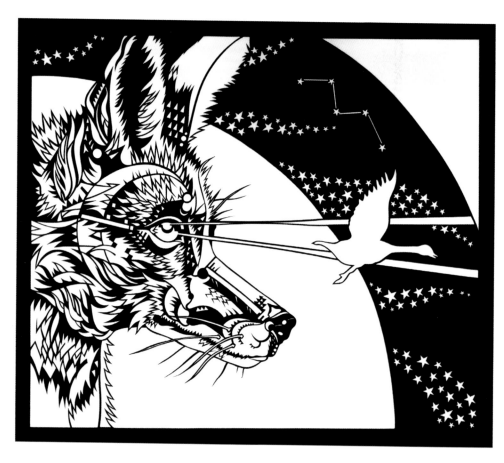

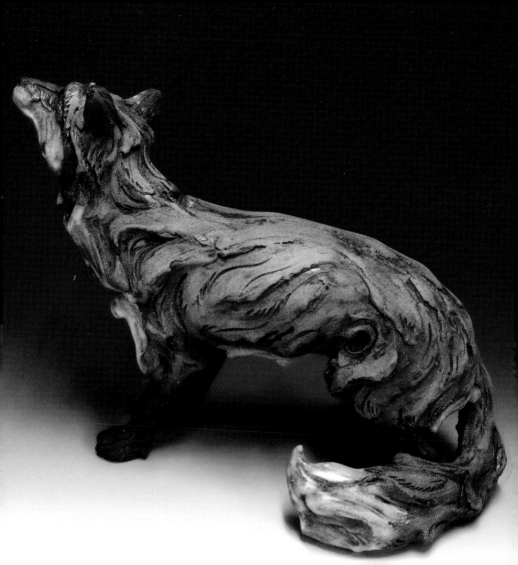

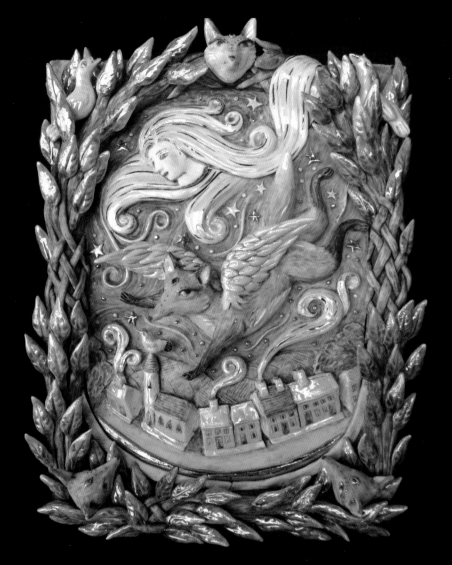

Photo credits and artworks by chapter

Front cover, page 24, back cover far right:
Margaret Holland
Back cover far left: Robin Gossage
Back cover second left: Mike Fenton
Back cover second right: Kevin Pigney

The Fox Project
page 4: Richard Steel
page 5: Photo ©DF Management
pages 6, 7: Maggie Bruce

The life cycle of the fox
pages 8, 13: Kevin Sawford –
www.kevinsawford.com

The urban fox & the rural fox
page 14: Maggie Bruce
page 17: Andrew Woodcock
pages 21, 22-23: Kevin Sawford –
www.kevinsawford.com
pages 24, 51: Margaret Holland

Sport or pest control
pages 29, 34: Mike Fenton
pages 33, 48-49, 52-53, 58-59: Maggie Bruce
pages 38-39: Kevin Pigney
pages 41, 44, 57: Richard Steel
page 42: Sarah Turner
page 54: Kevin Sawford –
www.kevinsawford.com
page 60: Kevin Pigney

The fox worldwide
page 62: Richard Steel
page 63: Mathias Appel
page 63: Marie Hale

page 64 (left): B. Peterson
page 64 (right): Neil McIntosh
page 65 (left): Rohit Varma
page 65 (right): artist unknown
page 66: Eyal Bartov
page 67 (left): Helmut Boehm
page 67 (right): Jeppestown
page 68: © B Moose Peterson / ardea.com
page 69: Tim Strater

Myths and legends
pages 72, 78-79: Library of Congress USA
page 75: Jolyon Russ
page 82: GanMed64
pages 84, 86 (bottom), 87, 89, 93: Artist
Unknown
page 85: Shinichi Sugiyama
page 86 (top): Artist Unknown
page 88: Miki Yoshihito
page 90: yt_siden
page 91: Artist Unknown
page 92: isado
page 95: **Kumiho by Pamela Speck
(Watercolor – July 2013) Violet Fox Visuals**

St Brigid and the Fox
page 97: **St Brigid by Frank Duffy
graphic designer www.frankduffy.co.uk**

The fox in art and literature
pages 106, 109, 110: British Library

page 108: © Ripon Minster by Eric Webb

page 110: © St. Botolph's Church, Boston,
Lincolnshire by Eric Webb

Acknowledgements

The generosity of the wonderful photographers and artists who have contributed to this book leaves me feeling very, very grateful. I could not have done it without you. Thank you all.

Special thanks are due to my dear chum Gilly Middleburgh, who yet again rose to the challenge of proofing my text.

Finally, I would like to thank Andrew Fusek Peters for his continued enthusiasm and support for my projects. His encouragement has hit the spot on more than one occasion. Thank you.

The Fox Book. Published in Great Britain in 2017 by Graffeg Limited.

Written by Jane Russ copyright © 2017. Designed and produced by Graffeg Limited copyright © 2017

Graffeg Limited, 24 Stradey Park Business Centre, Mwrwg Road, Llangennech, Llanelli, Carmarthenshire, SA14 8YP, Wales, UK. Tel: 01554 824000. www.graffeg.com.

Jane Russ is hereby identified as the authors of this work in accordance with section 77 of the Copyrights, Designs and Patents Act 1988.

A CIP Catalogue record for this book is available from the British Library.

The publisher acknowledges the financial support of the Books Council of Wales. www.gwales.com.

ISBN 9781910862551

Printed in China. TT140622

3 4 5 6 7 8 9

Books in the series

The Hare Book

The Fox Book

The Owl Book

The Red Squirrel Book

The Bee Book

The Robin Book

The Hedgehog Book

The Badger Book

The Puffin Book